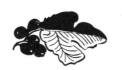

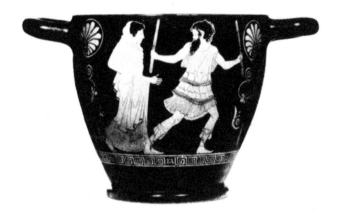

97A. *Athenian lady guided by a torchbearer in
silenus costume and hunting boots, on a skyphos
by Polygnotos*

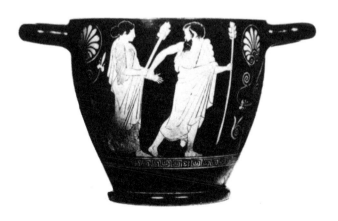

97B. *A less distinguished couple, on the other side
of the same skyphos*

Those Women

NOR HALL

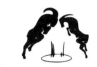

Spring Publications, Inc.
Dallas, Texas

Published 1988 by Spring Publications, Inc.;
P.O. Box 222069; Dallas, Texas 75222.
Printed in the United States of America
© 1988 by Eleanor Hall. All rights reserved
International distributors:
Spring; Postfach; 8803 Ruschlikon; Switzerland.
Japan Spring Sha, Inc.; 12-10, 2-Chome, Nigawa Takamaru;
Takarazuka 665, Japan.
Element Books Ltd; Longmead Shaftesbury;
Dorset SP7 8PL; England.

Library of Congress Cataloging-in-Publication Data

Hall, Nor.
Those women.

Bibliography: p.
1. Dionysus (Greek deity) 2. Mural painting and
decoration, Greco-Roman – Italy – Pompeii (Ancient city)
3. Women – Psychology. 4. Fierz-David, Linda.
5. Harrison, Jane Ellen, 1850–1928. 6. H. D. (Hilda
Doolittle), 1886–1961. I. Title.
BL820.B2H28 1988 155.3′33 88–4676
ISBN 0–88214–333–6

Contents

Acknowledgments

H.D. *Collected Poems 1912-1944.* Copyright © 1984 by the estate of H.D. Reprinted by permission of New Directions Publishing Corporation.

Color plates reproduced by permission of Scala/Art Resource N.Y. Frontispiece reproduced from C. Kerényi, *Dionysos: Archetypal Image of Indestructible Life,* trans. Ralph Manheim, Bollingen Series 65, vol. 2. Copyright © 1976 by Princeton University Press. The original photographs are from the Deutsches archäologisches Institut in Rome.

Mary Vernon drew the fig which appears throughout the book. The cover was designed and produced by Catherine Meehan Doehner and Sven Doehner.

Introduction

At the outset of this project, my intention was to write an introduction to Linda Fierz-David's unpublished manuscript on the women's rites of initiation depicted in fresco on the walls of the Villa of Mysteries in Pompeii. Her very hard-to-find work, which had been essentially hidden in private libraries of various C. G. Jung clubs and institutes, needed to be issued to a public grown wider in the decades since she had been translated by Gladys Phelan and made available to a select group of readers. While anthropological books on rites of passage and psychological books on midlife crisis increased in circulation, Fierz-David's contribution remained relatively unknown. The obscurity that is natural to books whose modus operandi is myth was ensured by the libraries' stamps "Not to be removed," "Privately printed," "For students — meaning initiates — only."

In the timely 1950s Fierz-David undertook a psychological excavation of C. G. Jung's individuation model, applying his findings specifically to women by drawing detailed parallels to what went on in this unique chamber in Pompeii. Ten scenes show an initiate (we think) making a ritual transit through an experience that moves, electrifies, satisfies. The God Dionysos reclines on the lap of an enthroned woman in the central scene, suggesting that it is her epiphany, his Mystery we attend. Dionysos "belonged to women." Sometimes called "the womanly one" or "the hybrid," he knew about femininity from the inside. According to the Jungian observer, he is the contrasexual element that the woman discovers

within herself and so "marries" in the *coniunctio* that crowns her journey to wholeness.

I will try to show another angle, but for now let it suffice that seeing the fresco series this way, as Fierz-David clearly does, gives a feminine version of completion like the Buddhist ox-herding pictures or the Christian stations of the cross – a complete set of images that expresses the complicated path of the psyche as it moves through the tortuous process of coming to know itself. The path is labyrinthine, meaning among other things that this route to maturity goes through a pit where a woman hides her deepest, darkest, unacceptable desire.

Esther Harding, Jungian analyst and friend of Fierz-David, wrote a laudatory introduction to the Villa manuscript in 1966. Because she is aware of the sexual charge within the spiritual excursion, her inclination is to guard the material. Which she does by proscription. Only "psychologically minded" readers should have at the content. Her voice has the weight of an appointed "maenad," a priestess of a Roman Dionysiac association, rather than the ring of the mythical maenad whose madness led to leaping boundaries of ordinary mental organization. Harding's concern is that initiation be educational. And her eye is on the image of "wholeness" rather than the evidence of disintegration that is strewn through any field visited by Dionysos. Her point of view does not put her out of the God's territory but rather one step removed. She takes a position appropriate for one who sees the room as a site of an Orphic cult. Orpheus too was one step removed from Dionysos. He represented the God in organized, purified form by cleaning up the savagery and emphasizing beatification – the blessed state of arrival.

Fierz-David and Harding shared an impulse toward mythologizing "the search." In this regard they joined the ranks of their contemporaries – women in adjacent fields – whose writing reflected their fluency in the arts and literature of classical antiquity. For example, the poet H.D. and, earlier, the classicist Jane Ellen Harrison focused their different studies on rites of initiation in ancient

Mystery religions. They used the arcana uncovered as imaginal data for "figuring out" a life. Gods and Goddesses roamed their sentences, turning up in their letters, plays, poems, conversation, and scholarly works as well as in their costume. Putting on the toga of their ancestors had a definite appeal for those women.

Fierz-David visited the actual chamber. The others visited the topic. In so doing they brought another kind of passion to the consideration of the images. Jane Harrison and H.D. were both open about their magnetic attraction to Dionysos. No caution surrounds their tributes. Their ability to lift the veil over certain chapters of their own narratives lets us in to the darker body of the material where we feel the breakdowns and miscarriages of hope. The analysts had a tendency to interpret images in the light of the end of the tunnel. Instead of staying in the interminable moment of the *katabasis* where the initiate "wanders as if dead," this analytical attitude posits an end in sight and in so doing relieves us of the burden of a labor which we would rather keep.

As the project expanded in intent, I chose to complement my review of the analytical attitude with the perspectives of the poet and classicist because they all were speaking, as someone said of H.D., "to a congregation whose reality is myth." Together they sounded as forerunners of the current call to see "psyche" – or the soul of it – returned to an ailing psychology. In fact, Fierz-David shows us how the woman in the fresco series who follows the course of the uninitiated soul in Orphic tradition resembles the patient who undertakes the long way through the unconscious as through the underworld. Harrison mapped this underworld. H.D. is its intimate.

In brilliant color, the walls recall stories from the company of Dionysos, bringing the losses and the ecstasies close enough to feel.

The red room speaks of labor, premature delivery, birth. Its language is that of initiation: gesture, position, placement of symbolic accouterments. Visually it stands as an "Imagist" poem. It is spare, eloquent, sequential, directly treating "the thing," and haunted by the sublime. A clue as to how to enter this chamber, which has invited inquiry since its turn of the century uncovering, came unexpectedly from the beginning of a performance by the composer John Cage, who paced the stage and said, "whenever I start a new work I walk around the room three times until I get myself to go with me." Of course these circumambulations overlap; nonetheless, there are three primary ways I have found myself reading the room. Mythologically as the scene of initiation that follows the tales of Dionysos and his female companions. As a depiction of the process of psychotherapy. As an account of rebirth, or of "coming to," by passing through the body of woman.

I have been fascinated as Fierz-David was by the contemporary look of the women in the chamber. Their liveliness makes recognition easy. Seventy-nine A.D., 1912, to the present – those women appear so like ourselves not simply because of the way they wear their hair or move but because of their gaze. They make eye contact with us. And their mouths seem to express familiar feeling. They touch each other and refrain from touching in a way that evokes our own memory and desire.

The women represented in fresco, and those women who were drawn to the same Mystery in later years, respond to the call of the wild God by taking up his instrument of power (the *thyrsus*) and using it as their own. In Dionysian tradition such women then became part of a company called a *thiasos*, a group bonded by their ardent mien, their enthusiasms, and an irresistible longing to swim in the same archetypal current.

This small book conceived as an introduction to Fierz-David's larger book became a separate tribute to a tremor in the subtle history of the women's movement. Fierz-David stood out as an example of a woman moved to extraordinary achievement partially

because she dared leave the loom of duty from time to time. I found that her attraction to Dionysos was not incidental. Unfortunately, her family regarded these perceptions as slander rather than tribute and made it clear that mine was an outsider's position. Which is true. I write from the point of view of a different generation but nonetheless one that has its grateful recipients. My gratitude and regret extend to Heinrich Fierz who told some of the stories included but who died before seeing his mother's work published. I am grateful to Mary Lyn Kittelson who conducted that interview on my behalf.

Thanks also go to many friends and colleagues, to patients, and to the willing participants in various "Dionysian Rites of Passage" workshops held between 1974 and 1986. To my family I owe thanks for inspiring the original curiosity about adventurous female ancestors, especially those Jungian women – aunts of mine among them. Although the scene of this work is the Mystery chamber in Roman Pompeii, it really begins with the need to fathom a mystery of identity. Who were those analytical women who embraced Jung's depth psychology with their whole lives? Why did so many of them never marry? I wondered where their peculiar strength came from and why they chose to study what they chose to study. The answers tendered in the text following are mine, the clews provided are theirs.

Nor Hall
June, 1986

Those Women

We knew how those women were. They wore tweed suits, sensible shoes, and were highly respected. We did not use the words *spinster* or *old maid* anymore except in card games, in reference to fairy tales, or to describe the unpopped kernels at the bottom of a bowl of popcorn. Those women lived in isolation in places like Switzerland and New York City where they had rooms, houses, or brownstones of their own, walked on concrete in winter and on pine needles in summer. They didn't have children (we thought), but they wrote books, and their love lives (if they had any) were shrouded with a blue haze that made one think of spiritual conditions. They were forthright, open-minded, clear-eyed, at least until the blue cataract haze clouded their vision late in life. But this only gave the impression that their inner vision was stronger.

They were emissaries of psyche. Vestals who had chosen to stay within the temple. They knew the catacombs, the labyrinth, had walked the Sacra Via, but easily crossed the bridge to the modern world where they taught YWCA courses in the 1930s on such things as "Psychological Mindedness for the Career Girl." They developed lasting friendships with women who shared the same goal of "making the unconscious conscious." We thought at first, in the distinction-eradicating blur of the 1960s, that this goal was like yoga, another discipline for attaining higher consciousness.

But those women (in our imagination) did not have the sort of bodies that practiced yoga. Their sturdiness lent itself rather to trail riding in jodhpurs, carrying heavy tea trays, books, and logs for the fire. The fires they kept burning (and here a bit of red comes into the otherwise pale blue and tweedy picture) were not the fires of frontier women warming water at the hearth to keep a household's hundred needs met, nor the fires of lanterns hung high in the gables

by colonial women who watched the black sea each night. Their fires were *inspired*. Intellectual illuminations lit by the flint of making connections. Olive Schreiner (*Dreams, Woman and Labor*) described her mother by this light – candlelight flickering in the room of their South African farmhouse. After the children were asleep she paced the floor with an open book, hungry for words. Driven, as those women were, by the Quest for Meaning. She was disciplined, hearty, heroic: such maidens were to become the matrons of a new psychological order.

Our mother was not exactly in the ranks – raising five children and juggling house and soul – even though she majored in psychology when it first became a collegiate choice. It was not mothers who carried the torch that would illumine the recesses of psyche's cave. How could someone carrying a baby and bearing her myriad daily responsibilities also wield the fiery brand that would light up that shadowy place? The women who had won this impressive renown were always one step removed: aunts, sisters, stepmothers. Unattached women (or so we thought) who were pulled by uncanny insight like Hecate in the mother–daughter story. One of her attributes was phosphorescence. Match-like, quick. Unattached women made connections that flashed brilliantly in the dark. Or, by day, their brilliance was a bit like sunlight glancing off the shield of Athene. A bright but cold and deflected spiritual sparkle. The body beneath unwarmed. And like Athene, they were dedicated to maintaining order, peace – a sense of decorum and sobriety – not the sort of qualities that would indicate an interest in things Dionysian.

The hint of fire and the suggestion of compulsion bring us to the question. What brought those dignified matrons (as we envisioned them across the bridge of lore spanning a two-generation gap) to the women's room that had been excavated in Pompeii in 1912? The central figure in the fresco series running clockwise around this small, intense chamber was a woman seated on a raised throne with the languid body of a beautiful, young Dionysos draped across her lap. The subject of this newly discovered chamber exerted an ex-

traordinary pull, drawing women to study the dramatic detail that had lain covered under twelve feet of solidified ash since the deadly eruption of Mt. Vesuvius in 79 A.D. Finding a perfectly preserved room decorated with ten panels that could be read as a story was unusual. But the fact that the story appeared to be part of an initiation, and especially an initiation for women, made the room unique.

The original women painted on the walls of the mystery chamber, as it came to be called, defy easy classification. Are they maidens or matrons? They wear wedding rings. Yet these women in various states of dress and dishevelment, who are sensually framed in shocking red, are not new, young brides. To whom or what are they giving themselves? And the women who have come here since, the upright and seemly (the "blade-like maiden ladies" as the collater of C. G. Jung's *Visions Seminars* was once described), the discerning classicists, archaeologists, poets, and the psychologists. What brought these analytical women here with such reverence? Why did they—who seemed to have sprung from the cool forehead of an awesome God, who seemed so comfortable with the heights—go south to Italy, to Pompeii of all places, into Dionysian territory?

A number of years ago on a naïve pilgrimage to a summer watering place of the North American analytical psychology set, I happened to meet one of those women about whom this mythology had so elaborately evolved. Nearly ninety now, she lives alone five months of the year on a granite-walled, rosaragusa-covered island in a cottage of her own design. The windows are set so that she appears to be floating in a great boat. Out of the living room by day one sees only the vast watery horizon and, by night, the path of the moon, occasionally crossed by the moving lights of the ferry to Nova Scotia. In the corner there is a small, semi-circular built-in

desk for correspondence, with a Swiss-chalet music box on top. A comfortable couch faces the fireplace. The exterior stonework on this fireplace was appreciated by Dr. Esther Harding, who could see it from her window across the bay on Spruce Point. In the middle of my friend's room, there is a typing table that has been the setting of her psychological work for over thirty years. Every day she attends to "the play," the vivid drama of inner characters who move and speak, dance and sing, run riot, calmly garden – doing the things that her body can hardly do.

Outsiders are aware only of her solitary nature. The man at the inn down the road talked about her as if she lived in a cave halfway up Mt. Parnassus: "She's hermit-like, doesn't talk to anyone, but if you told her you were interested in psychology. . . ." He had been a cook's assistant at the conference in the 1930s when Jung himself came to the island. The innkeeper had grown up knowing about those women. He was the one who pointed out the Harding house on that moonlit climactic night of the pilgrimage: "The doctors lived over there. There used to be a lot of them around every summer. Odd group of women. If you ask me, all they needed was a man."

As we stood out there on that rocky out-cropping in the moonlight that cast shadows of pines on the moving sea, the wind blew salty and cold, seemed very cold for September. We were not exactly in Dionysian territory, or were we? "Dionysian," in common parlance, tends toward the hot end of an emotional spectrum. Hot and wild, the revel rout, temperatures raised by wine. This is not altogether wrong, just incomplete. Coldness and silence are as essential to Dionysian experience as the heated pandemonium. There is the coldness of Ariadne's abandonment on the sea-swept isle of Naxos – an aloneness that prepared her for meeting Dionysos. There is the cool storage required in the process of wine making. And the cold which the maenads dashed into, draped in animal pelts, looking for the divine child in mid-winter.

Our New England guide saw "them" as cold, distant, and unrelated. He was not as curious as Pentheus in Euripedes' *Bacchae,*

but his description was a tamer, more reticent version of the Theban king's, descended from the attitude that what women do at night, alone (meaning also in the company of each other), is "deviant and smells a bit rotten."

Dedicated as they were to the introversion of analysis, those women on the island in Maine did not actually band together very often – only on Sundays for brunch or tea. Yet their shared devotion to what goes on in the darkness, to dreaming, imagination, to "the suprapersonal," and to C. G. Jung banded them together in a loose-knit but fiercely maintained community of believers like the original *thiasoi,* the roving bands of sisters who attended the God.

The Dionysian train included women – his nurses, maenads, or muses – and a motley crew of rustic creatures: horsemen, goatmen and sometimes one man who functioned to keep other men away. The groups were evocative. They responded to the earth-shaking din of the God's call by calling him with loud shouts of "Come!" And they were provocative, rushing out periodically to arouse his sleeping form in the *liknon* (a shoe-shaped winnowing basket or fan, see Scene 7) where it had slept during the previous year.

At Delphi and at Elis there were colleges of such women, with presidents. One called Klea was a friend of Plutarch's who recorded a conversation with her at the time when the Villa of Mysteries was probably being used by Roman women for the initiation rite. They discussed the relationship between the awakening of Dionysos and the mysteries of Osiris, the earlier Egyptian God who was dismembered, scattered abroad, and remembered. The maenads first, then the priestesses and leaders of *thiasoi,* and then the colleges of women stand at the beginning of psyche's long tradition of greeting the return of the Gods – a tradition honored by Freud with his collection of divine statues in the consulting room, and Jung with the engraving in stone on the lintel of his home, "Called or not called, God will be there."

Dionysos is particularly prone to coming, whether or not he is called. To those who are stationary, he comes like the locomotive in

Magritte's painting: bursting insanely into the room, penetrating the hearth space. No place is inaccessible to the Penetrator, especially the center of the household where the Penates stood, the household Gods whose name, derived from *penes*, meaning "the inside" or "interior of," is related to penetrate and penis. In fact, his call is issued to the housebound – to housewives, diligent daughters, anyone confined by the structures lived in – that is, when structure is stricture and one is unhealthily stayed. When the elemental in one's own nature is repressed (according to the resistance theory), the God's violent coming is a punishment bringing about "the sudden complete collapse of the inward dykes when the elemental breaks through perforce and civilization vanishes." (Dodds, 273)

Our dreams announce these "sudden complete collapses" associated with Dionysos. (His impulse can show up in the turn of the dream text that says "suddenly. . . .") For example, a woman on the verge of breakdown dreams that she is "tying a man to a breakwater in the river." His name is Lord Germinator. He wants to know why she is doing it. Soon, she is tied up too and asking him not to look into her eyes because they will betray her hostility and fear. He knows that when the time comes a huge timber will be released, breaking through the bulkhead. "Suddenly, the timber crashes through and flings us into the torrential river. I am now the man separated from the wife, the life raft, the houseboat, the civilization on shore. It all vanishes, leaving me helplessly caught in the flow. I will have to make do as well as I can, maybe floating for a week and a half." Which was, she discovered in pursuing her image, the amount of time it takes a seed to germinate.

Plutarch and Klea discuss Dionysos as the "principle of moisture" or "the liquid element." Jane Ellen Harrison (430) thinks the poets and the people would not have used such philosophical jargon, but would simply call him He-of-the-Trees who runs in the pine and in the liquid shower of the vine. In any case, our discussants compare Dionysos to his Egyptian counterpart, to Osiris as the "force of ger-

mination." He-of-the-Seeds, seedlings, and scattered male seed. They call him Lord-of-All-Wet-and-Gleaming and say that the Paphlogonian people enacted the belief that the God is bound in winter, but stirs and is untied in spring. Dionysos brings this seasonal frenzy that urges letting go.

Meanwhile, the dreamer drifts in her breakthrough. S/he is within sight of, but not reach of, a houseboat – a place for mooring the imagination, for possibly housing it without being housebound. In the *Bacchae* "the call" comes to those who have become so accustomed to city life that they have forgotten the feel of water rushing over their bodies – though the image is more delicate, of rising from sleep to running and feeling "dew on the throat and the stream of wind in the hair." Housebound souls are out of touch with the elements, with the pent-upness and wild release of the river, with the thunderstorm that brews and breaks, with the throbbing of blood in the veins of a young animal, with the steady, slow and sticky amber drip of pine trees: bursting, flashing, throbbing, and dripping – the magnificent sexual acts of nature that suggest the undomesticated presence of Dionysos.

"Housebound" describes a psychological state of being. It does not refer only to the women who are married, unemployed, and at home with children. If our understanding of the term were limited to this actual restricted condition, we would be at a loss to discover how the call of Dionysos had reached and intrigued those women who were atypically free, being highly degreed, well-to-do, scholarly accountants of the humanities. Some of them, it turned out, did have children, including Linda Fierz-David who spent years of her active intellectual life interpreting the frescoes in the women's chamber at the Villa from the point of view of the individuation psychology of her analyst and colleague. The extended title of her unpublished work finished in Zürich in 1957 reads: *Psychological Reflections on the Fresco Series of the Villa of Mysteries Pompeii: The Initiation Way of a Roman Woman of Imperial Times Interpreted by a Modern Woman from the Standpoint of Jungian Analytical Psychology.*

Linda Fierz-David had raised four sons when she turned to this particular work. One of those sons, when asked if she was the sole mother in the circle of women writing around Jung, said that she was one of the very few. Did she have difficulty finding time to do her work? "This was not a problem for her. She began writing when we were in high school. Also this was after the war when a professor like my father had three housemaids." Did she spend time with her children then? "She was always available before and after dinner. For vivid discussion, fairy tales (which she made up and compiled into a little book), singing classical songs, and playing the piano. Through these activities we learned archetypal motifs. When we were well occupied with school activities, she would be involved in gardening or writing."

Such privileged and talented women were certainly not housebound in the modern sense. They were not overworked, isolated, and domestically entrapped. They made their own ways into the world by becoming the first women in critical twentieth-century endeavors. Among them were the first medical doctors to become analytical psychologists (Kristine Mann, Eleanor Bertine, and Esther Harding – the "Doctors" of Bailey Island), the first women to get Ph.D.s in Health and Physical Education (including my friend Ethel Dorgan), first to study and then teach at Cambridge.

But here I am slipping into a broader category by including women like Jane Ellen Harrison, the famous archaeologist, scholar of antiquity, of Greek religion, and of Dionysos in great depth. She belongs to the company of those women by virtue of precedence rather than acquaintance. She died in 1928, seven years after writing her concise *Epilegomena* which she prefaced with an acknowledgment of her debt to the psychological work of Jung and Freud. In this respect she is one of the circle who would note the play of the Gods in the human psyche.

Another reason for her presence here is her classical flare as teacher, her "style" (a word used often by our elders when recalling one of "those women"). Her lectures were performances designed

with the archaeologist's skill of breaking new ground and the dramaturg's understanding of when to break light upon an undisclosed scene. Her student and friend Francis Cornford described her dramatic figure on the darkened stage of the lecture room "which she made deserve to the full its name of theatre." Cornford said:

I have a vision of her . . . a tall figure in black drapery, with touches of her favourite green and a string of blue Egyptian beads, like a priestess's rosary. The rather low voice vibrated with the excitement that had been working in her for many hours of preparation. The hushed audience would catch the nervous tension of her bearing, even before the simple conversational tones began to convey the anticipation of some mystery to be disclosed. (Stewart, 20)

Once the veiled object on the side table proved to be a *liknon*, the winnowing fan of multiple uses that appears in the Villa frescoes holding the phallic herm of the God. Another time she enlisted friends to break into the back of the room in mid-lecture, swinging bull-roarers to create the terrifying whirl of sound announcing the arrival of fearful semblances of the Dionysian company. Another friend beat a drum "like thunder underground," charging the air with dread anticipation. "Every lecture was a drama in which the spectators were to share the emotions of 'recognition.'" (Stewart, 20)

Recognition. More specifically, she called up the emotions of recognition, the feeling that you are seeing and hearing something you can identify from your own experience. This may not seem as much of an achievement to a generation brought up on the novels of Mary Renault, who fictionalized the Greek and Roman myths for us. Or for current academics who are accustomed to interdisciplinary studies that include reference to various fields of experience. But Jane Ellen Harrison was a first here, too. Because she was a student when Schliemann was digging up Troy, she recog-

nized the significance of the artifact and was the first professor to in-
clude archaeological field-work material in lectures on classical
literature. Her critics accused her of "dragging in" everything:
psychology, anthropology, philosophy – apparently even feeling.
When she said, while showing a stone relief of a Goddess (was it
Hygeia?) fading into obscurity behind a God (was it Asclepius?),
that "our hearts are sore for the outrage done to the order of ancient
goddesses," she sent out a distress signal that still resonates in our
atmosphere.

Lecturers who work this sort of rooted matter (history rooted in
artifact, myth rooted in psyche, words rooted in origins) know that
they are "on" when they have struck a deeply resonant, impersonal
chord in their listener. It is impersonal because it is archetypal,
potentially shared from the beginning by everyone – like the place
struck by the dramatist who knows no one in the audience per-
sonally, yet whose scenes make individuals tremble. The excitement
arises personally because we are all looking (with Yeats) for the face
we had before the world began and are tremendously eager for
those rare glimpses of recognition.

Antonin Artaud, for example, catches the reverberation of the
priestesses' gestures still in the air. When he describes the effects of
the Balinese theater, he says that the

> excessively hieratic style, with its rolling alphabet, its shrieks of splitting
> stones, noises of branches, noises of the cutting and rolling of wood, com-
> pose a sort of animated material murmur in the air, in space, a visual as well
> as audible whispering. And after an instant the magic identification is
> made: WE KNOW IT IS WE WHO ARE SPEAKING. (Artaud, 67)

If the word *magic* means "working at a distance" and *identification*
implies "recognition of an image," then the state he alludes to in
this rumbling passage is quite similar to the one effected by a good
(imaginative, rooted) lecture of the Jane Ellen Harrison dramatic
and – I would venture to add – Dionysian sort.

I do not know that Linda Fierz-David lectured on Dionysos and Orpheus with visual or sound effects on site at the Jung Institute in Zürich in the early 1950s. Nonetheless, the material collected in her manuscript has this God's flare about it. It is periodically epiphanic. Breakthroughs of emotion, subjectivity, and fantasy make her "scientifically objective" text sparkle. These moments of breakthrough often come with an apology appended or implied.

For example, there is an intriguing spacing mistake in the portion of the text where she discusses the back wall of the mystery chamber. The translator tells us that an entire paragraph, in which Linda Fierz-David "gives rein a little to her fancy" about the possible use of a dark tunnel running underneath the chamber, was set apart from the main body of the text by single-spaced type. The translator regards it as a typist's error, but the author makes it clear that she is stepping outside a boundary of objectivity in a brief fantastic interlude. This episode in the construction of the text points to an underlying problem of what belongs to a psychological work, especially to work that evokes a particular God. Breaking boundaries, whether it be of syntax, content, or style, is a peculiarly Dionysian vehicle for the conveyance of new material.

When we puzzled aloud about the apparent (to us) conflict in Linda Fierz-David between observation "according to the scientific methods of modern psychology" and observation based upon imaginative leaps, Heinrich Fierz told us this was no problem. In fact he said that his mother "would be astonished hearing this modern question. She mixed it up in a natural way." With equal parts intelligence and intuition, according to Jung in his introduction to her work on *The Dream of Poliphilo*, she leads the reader through labyrinths of obscure symbolism. He praises her for being his Ariadne. Dazzling interpretation and tactful indiscretion permit her to dare lift the veil to "peep behind the scenes." Because she is a woman, she moves easily in realms he did not explore. For example, in the realm of women's relationships to women. Here she could not be faithful to Jung's findings (because there weren't many, with

the notable exception of the idea that same-sex figures function as shadow selves and therefore we need them). So she followed closely the configurations of the women in the frescoes instead. Looking at their gestures and postures as they moved in relation to each other. In this way, when she adheres as much to the image as she does elsewhere to theory, she defies conceptual constraint and works the kind of "magic" mentioned above. She brings distant figures up close so that we know in a moment that it is we who are looking at ourselves.

"Recognition" must have been the key to why those women (in this instance, I mean Linda Fierz-David and later Esther Harding) were drawn so powerfully to the Villa and why, once they were there, they felt a mysterious presence, a certain headiness, almost as if the giant *pithos* (wine jar, jar of spirits) stood there still open in the center of the chamber. They say the attraction was to the "individuation model" afforded by the fresco series. Or to the remarkable specificity with which the "initiation way" parallels the psychological development of modern women as elucidated by "Professor Jung's analytic method." Undoubtedly, the confluence of individuation theory with the stages of a mystery ritual excited the Jungian observer.

There is, however, a greater pull in these pages, an erotic undertow not explained by that confluence alone. Harding and Fierz-David both wrote books based on the archetype of individuation in which the solitary pilgrim's progress demonstrates a recognizable path of psychological development, but these books—*Journey into Self, Dream of Poliphilo*—which ostensibly work ground similar to that covered by the Villa manuscript, do not carry the same charge. The difference is that here the women they are looking at are remarkably like themselves: "the highborn, the seemly, the progressive, the educated." With these words, Linda Fierz-David describes the matrons in Livia's circle who retreated to the Pompeiian countryside to attend the sequestered rites in which the shady qualities of the other side—the low, the unseemly, the regressive,

the uneducated (Harding says "initiation is the education of the emotional life") – play ritual havoc with propriety.

Could this be the reason those women were so attracted to these Mysteries? That maenads roamed beneath their seemly personae? Beneath the formidable forehead and shabby dress of the scholar (as Virginia Woolf describes the "elderly JH," who we know is Jane Ellen Harrison, walking across the club lawn in *A Room of One's Own*), there flashes the memory of the brilliant young woman whose imagination, enlisted by the epiphanic Dionysos, shook the staid lecture halls of Cambridge.

Dionysos is the Shaker, the Loosener. He is that trembling energy that shakes the maenad loose from the confines of complacence. Dionysos is the unexpected apparition. His appearances were called both *epiphaneia* and *epidemia*. His epiphany took the form of an epidemic "spreading like wildfire among women" and "making the edifice of Apollo tremble." Everything edifying – ennobling, spiritually uplifting, morally elevating, improving: these massively built defenses against the downward pull of instinct – trembles and crashes as resoundingly as the stone palace cracks and falls around the lovely stranger (Dionysos) that a mad king (Pentheus) tried to imprison.

This locates the place of seizure as that place most carefully guarded. If, for example, one has been raised to be "good" according to any tradition with ingrained standards of decorum/decency/dignity (all related to *dogma*), the seizure would occur in exactly those places where doctrinal decency is maintained. Foundations of identity tremble when the edifice is shaken. If marriage edifies, if a person's moral identity is tied up with "that forge upon which character is melded," then it is marriage that trembles when Dionysos approaches. If it is a career that builds strength of character, the discipline begins to waver. If it is power that edifies, one's sovereignty crumbles. Physical trembling announces the imminent takeover. We shake like a leaf when a resistance is about to break. There is the ultimate "tremble unto death," the virgin trem-

ble before sex, the tremor of voice before registering a newly felt emotion.

Musical instruments actually shown on the mystery chamber walls – the woodpipe, lyre, and tiny tympanum – and instruments implied by what we know from other Dionysian ritual sources, the drums and bull-roarer, have this tremulous quality. The softly quivering, sometimes strange disturbance in the air created by the flute and strings is related, as tremulous is to tremendous, to the loud, resounding drumbeat that disturbs the lowest *chakra* urging the initiate to run or dance. Strong movements in response to the *mysterium tremendum* are evident in several of the maenads' many names. They are called the Rushing, Raging, Trembling Ones, and the Ones Whose Hearts Beat Excitedly Under Strong Emotion. Fear mingles musically with excitement. Tension mounts. Anticipation rises. In the frescoes we see the woman frozen, caught by the call. At this frightening pivotal moment (Scene 4), the question is "Will she go?"

On vase paintings we see the first movement in the rising crescendo: a girl swings back and forth over the intoxicating *pithos*. Her swing is decked with flowers. This is the day of "The Cups," day two of Anthesteria, a three-day wine festival of Dionysos. In the night between "The Cups" and "The Pots," the Queen will be escorted to the bull stables where she will enact a mysterious ritual "mix" with the God. (*Meixis* is animal copulation; *symmeixis* is a human marriage, copulation done with *koinonia*, companionship – a "higher" form of mixing. Aristotle said that what the Queen did was *symmeixis* and *gamos* which is the physical union that consummates a marriage. This sounds accurate for the sexual encounter of a woman with the animal form of God.)

In any case, the girl is getting high on her swing, hovering in the mid-air paradox of the spirits released beneath her. The spirits of the underworld (the dead are also buried in *pithoi*) breathe when the wine breathes. Her swinging is a sort of foreplay leading up to the

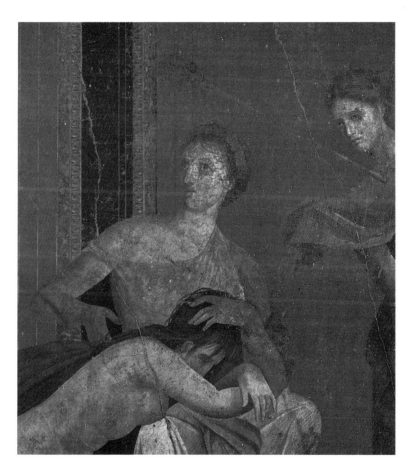

Detail of Scene 8

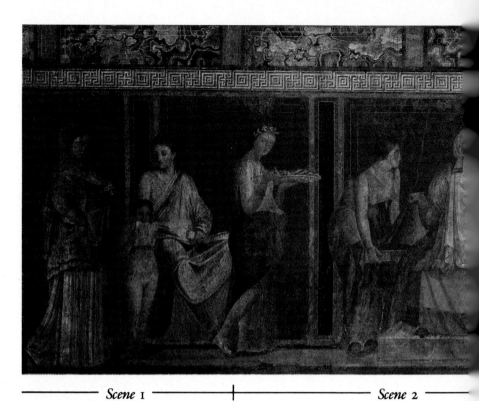

Scene 1 | Scene 2

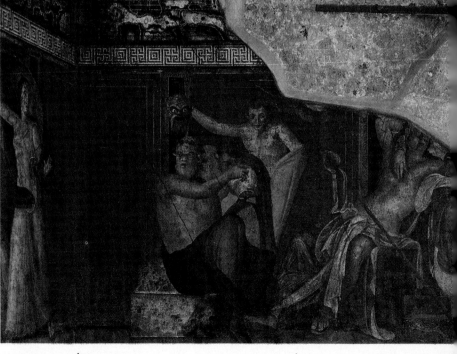

Scene 4 | Scene 5 | Scene 6

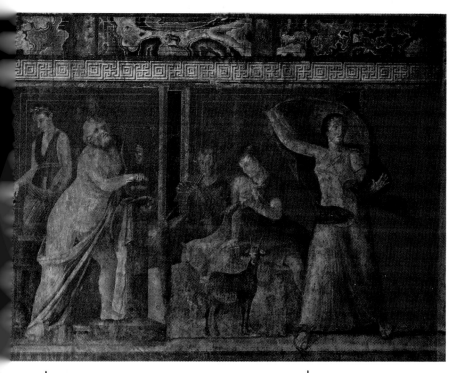

Scene 3 ———————— Scene 4 ————

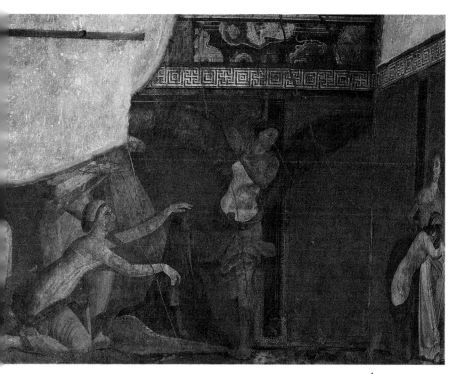

———————— Scene 7 ———————————————— Scene 8 —

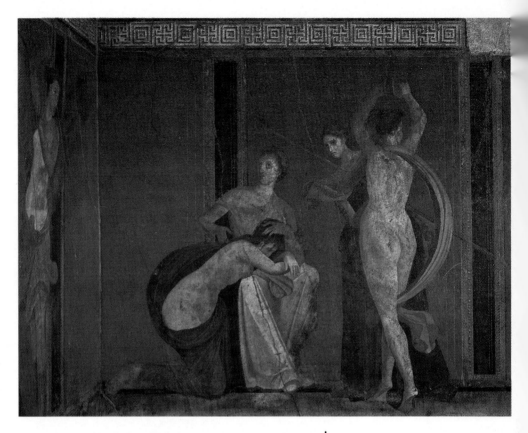

Scene 8A ——————————┼—————————— Scene 8B

Scene 9 ——————————— Scene 10

seductive events of the coming evening. She experiences the spiritual rush and the arousal of the women who will escort the Queen out into the far field. But she will remain at home, unattended, still swinging and waiting for the stranger who will appear to lead her to the revels in the hills. Only women are involved in these nocturnal rites. The men sit off to the side, in-between the temple and the swamp, drinking in silent rounds punctuated by the eerie sound of a trumpet blast. This instrument, called a *salpinx*, was sometimes hidden under a leafy cluster at the top of the "ivied javelin," or *thyrsus*, carried by followers of Dionysos. This identifying staff was made by stuffing ivy and pine boughs into a hollow stem of giant fennel. *Salpinx* means "trumpet-shaped tube" and is currently a term for fallopian tube. The blasts announce two forces of conception about to meet enroute.

At home the young woman greets her caller. He comes (on another ancient drinking vessel, see Kerényi, pl. 97A, B, reproduced in this book) to take her by the wrist. The stranger sports the pointed ears and hairy visage of the animal man who lurks about the dancing ground. Both he and the maiden carry the miracle-producing *thyrsi*. ("One of them lifted a thyrsus, struck a rock/and water gushed from it as cool as mountain snow./Another drove a stick into the ground/and at the bidding of the god,/wine came bubbling up," so the herdsman reports on the maenads in the *Bacchae*.) If we could follow them off the vessel, we would next catch sight of the maiden in maenadic posture, head tossed back, hair flying, aroused by the Bacchanalian beat toward violent heights of ecstasy to which the more gentle swinging earlier that day referred.

Another couple moves across the opposite face of the drinking cup (97A) – "more distinguished," according to Kerényi, who describes the woman: "Her facial expression, dress, and head covering are not those of a bacchante." (She is not frenzied, costumed, maddened.) "With wide-open eyes she strides forth to an unknown adventure. . . . [which] is probably similar to that of the less distin-

guished couple on the other side. . . ." (Kerényi, 313) These two carry torches, suggesting that the woman will *see* something in the night. Their elegance of costume and bearing hints of sublimation.

All our young, flowery, swinging lives – while the fantasy of *those women* gathered bits of information to itself – we were being drawn to the image of this forthright, striding woman. Even as we blossomed and sported, preparing unwittingly for the move into the passionate play of adolescent sex, we were consciously attracted to the seriousness and the intelligence of that wide-eyed woman who reached for the torch, the "brand to light the darkness we move in." (Levertov) Then each of us found – as any girl does when the cup is passed to her and when she has only been given part of the picture – that there was this entirely other rude and un-distinguished side to answering the call. In our house one's "calling" had to do with the idea of vocation – preferably one that would serve to glorify a God. No one ever *said* it could not be Dionysos, but the Christ-centered teachings left more room open for Orpheus the Good Shepherd (forerunner of Christ in temperament) than for Dionysos, whose tendency to drunkenness threatened the edifice.

What we did not know then, when considering lovely renditions of Orpheus and the beasts in the Peaceable Kingdom, was that when Orpheus tamed the animals with his music he was taming Dionysos. He was the missionary of that wild God. A solitary wanderer, singer, musician, and writer, he wrote hymns to Dionysos, organized initiation material, and established a set of spiritual doctrines that were beatific – and bloodless. In his hands the *thyrsus* that had been the exquisite instrument of frenzy – caus-ing madness, inflicting injury, orchestrating the dance – became an instrument of peace and order. In the second century A.D, we were told, it was used to enforce rules of proper behavior in the meetings

of Dionysiac associations. If someone misbehaved, a steward, as stern and as unbending as the staff itself, set the *thyrsus* down beside the offender who understood this gesture as his signal to leave the hall. Thus, the crude, inciting stick became the refined meter of propriety, and the impulse to go wild is restrained.

Kerényi's analysis of the scenes on the cup persists in a separation of elements that would have appealed to the Orphic reformer whose interest in purity encourages a certain denial. Once a thing is refined according to this perspective, it is no longer attached to its crude base. Accounts of what happened that night during Anthesteria seem, at first reading, to justify the split. We have mentioned the young women's instinctive response to the call. The older women, represented by a chosen group of fourteen *Gerierai*, form the Queen's procession in a manner reminiscent of their more ancient sisters at the College of Elis who called for Dionysos: "Come Noble Lord, with your raging bull's foot, Come!" They go to the stables where the Queen enacts something, and they see something. They do not enter, but an image is shown to them – much like the ear of wheat that is silently shown in the great rite of Demeter at Eleusis. But this would be something that "stands for" Dionysos: a herm, a phallus veiled – or the child swaddled and lying in the basket. The image of what makes the *gamos* sacred mysteriously alters before our eyes: first it is a baby, now the "shaft of god," each connected to the other by their intimate knowledge of a woman's body.

While the younger ones dance ecstatically through the night, the older ones move in orderly rows toward a mature revelation of the same mystery. According to Diodorus Siculus, the function of the *thiasos* was different for maidens and matrons. Young maidens carried the *thyrsus* and joined in frenzied revels with shouts of "Evoi." And maidens made sacrifices to the God, celebrating the Dionysian festival in groups.

When we look at the cup in question again – and recalling what an art historian said once, that erotic scenes on Roman drinking vessels show one couple engaged in different postures on opposite sides of

the same cup – it seems likely that the dignified woman and the un-dignified woman are one. She looks quite the same. Only she goes bareheaded and with undraped arm in the scene with the satyr who grabs her wrist. (97B) The need to distinguish so literally between matronly and maidenly ways of proceeding to the God's celebration does not come so much from women's experience as it does from seeing through the eye of Orpheus.

Orphism as a "masculine, speculative tendency within a religion having women's cults at its core" (Kerényi, 262) tended to separate women from the truth of what they know about themselves by superimposing a theological system on an orgiastic religious ex-perience. *Orgia* are not "orgies," but acts of devotion stemming from the same root as *ergon*, "things done" in a meaningful manner. Orpheus quelled the ecstatic *orgia*. Suddenly, the image of the Dionysian mystery religion is drained of red. Like Calvin, who was appalled by the richness of the Roman liturgical gear in more recent history and would allow only natural wood and simple white linen in the place of worship that had been gilded, brocaded, smoky and wine-scented, Orpheus whitewashed the Dionysian mysteries. He took away the wine, dressed the body in white, took meat out of the diet and the raw beat out of the music. His appeal is to a higher *chakra*: purified, abstract, transparent, beautiful, dignified, and ascetically pleasing. Baubo, the impish, iambic Goddess who stirs women in the bowels and who figures importantly in the Eleusinian mysteries precisely for her humor and impropriety, has no place in the new system emphasizing right conduct and immortality in the next life. Not only is the so-called lower body denigrated with its conduciveness to miraculous physical transformations in *this* life (consider the event of lactation, or an erection, for example), but also the entire body of experience on which the cult was founded comes to be considered "lower."

In mythical fact, Orpheus refused women participation in his rites and made his preference for a male audience obvious. Seeing women through an Orphic eye shaded by fear and unfamiliarity

(Orpheus lost Eurydice early on – significantly to the "lower" world – and they say his rejection of woman stems from bitterness over that loss) would make subtle appreciation of the feminine unlikely. From that point of view, a woman is either frenzied and young or dignified and mature – probably in that order. It may well have been true that older women moved slowly and younger ones impetuously, but the important point psychologically is that there are different feminine modalities for attaining the consummate union with the God.

The vigorous, rhythmically induced ecstasy mimetic of love-making differs from the matronly meditative reflection on an interior drama. A maenad – to consider the first mode – in orgasmic posture is not making an orderly sacrifice to the God. She *is* the sacrifice in that she is totally given over to the "body electric" as if charged by friction, the brilliant *electricus* of silk-rubbed amber, the shimmering, resinous, hardened essential sap of Dionysos. Ecstatically drawn – neck stretched, toes stretched – roused, reaching, running, and just as suddenly dropping, she is intoxicated. Licked by fire. Not the lambent flame that gives Orphism its translucent spiritual quality, but the roaring flame of the dark God whose coming creates the epidemic among women that, Pentheus said, "spread like wildfire."

Light streaks differently around the bodies of the older, torch-bearing women. Theirs is an evening procession lit by the contained fire of maturity, knowing the favorable moment (*maturus*) for viewing. These women arriving are at the heart of the mystery – they are coming around to the position of the *matrone* (Scene 10) who knows the passageway, like the overseer in a medieval garden maze who sat on a central elevated perch witnessing the bewildered moves of the entrapped. Only she is more empathic. From the far corner of the mystery chamber, where she still sits in an armchair slightly raised, she looks as if she remembers each turn of events. The one who has arrived (the Orphic initiate declares, "I have arrived") sits calmly and warmly watching. She who also once caught

fire, took up snakes, danced with the God, met the bull head on, and suffered the descent into madness now sits facing the central fresco image of Dionysos leaning on the lap of an enthroned woman. Is she looking back at herself? Does the glance of these women sitting opposite one another intersect so that they see each other (one who is coming, one who has arrived)?

Now that we have noticed the line of vision connecting the two women at the front and back of the chamber, is it the initiate and the *matrone* as some suggest, or is it Ariadne and Semele, beloved wife of Dionysos and his longed-for mother? Dionysos was wont to confuse his mother for his wife. For years of his life, he wandered in search of the woman who died when he was born. As do all men look for their lost young mother when looking for a woman to wed. Semele died when seven months pregnant because, when she asked her unknown lover to reveal himself as he truly was, he came to her in the deadly magnificence of a lightning bolt. Out of disguise he was the great God Zeus. He reached for the unborn child, opened his own thigh, and sewed the child in, securing his "womb" with golden clasps. When the child Dionysos leapt forth "twice-born," once from his mother, once from his father, he was given into the care of Semele's nurse who raised him, hidden in the mountains, disguised as a girl.

This apparent "girl with the heart of a boy" grew in loveliness and strength until he was ready to go search for his lost mother. In one account he was wandering over the sea and came, forlorn, to the Isle of Naxos where he thought he might find her. Just then, Ariadne had awakened from the sleep of her marriage night to discover she had been abandoned by Theseus, the mortal hero and husband who had brought her this far out of the labyrinth of her girlhood. Her impulse to throw herself over the cliff met his drive to find Semele, and they embraced in mid-despair, he thinking he'd found his origin and she thinking it was her death. The myth singers say she had been betrothed to the God from the beginning,

but it was not until she found herself utterly alone, betrayed, and deserted that she could locate this other undying masculine force that was primordially hers.

Standing in the chamber, we are riveted by the multiple lines of vision glancing off the walls, mirroring and connecting women represented in various stages of this rite of passage. Because of the missing fragment where Ariadne's head would be (Scene 6), we cannot be certain where she looks. But the *matrone* seems to ponder in her direction. Her reveries are weighted by the image of that momentous encounter. The reviewing eye of this woman, also called the *Domina* (the woman who holds this domain or house together), puts together what the Orphic eye would split. She who has been through it knows that the women shown on opposite sides of the vessel are one.

The description of the *thiasos* in the *Bacchae* gives a multifaceted image of the woman who becomes a maenad. She is not only one age or one type. Nursing mothers are specifically mentioned. Whether the maenad be maidenly or matronly, the important fact is the ability to let down or let go. Little girls do not follow. Those who do are of age to "attend the rites of maturity": women in the middle stage, not pre-pubescent and not among the old ones, but those in-between who most intensely feel the body's demand to respond to Dionysos.

This is not simply the demand "to make life" as the poet H.D. says of the Eleusinian initiates when telling her female lover why her mother thinks she should marry Ezra Pound: " . . . Mama doesn't hate you. She is in another world. She and Lilian [Ezra's mother] are Eleusinian. Life to them means simply more life. They have justified themselves in having children." (1981, 179) Women's response to the call does not produce children; it does not serve the family in any way. Women engaged with women who are engaged with Dionysos excite themselves. Their passion does not result in literal offspring.

The spring-off goes in other directions. Maenads are nurses. They take care of wild things, sometimes taking care to sacrifice them, to devour life raw and fast and unrefined. An offspring of maenadism is a woman who is "touched." She has been touched by the mad enthusiasm that bursts bonds of habit and decorum. In his Theater of Cruelty (read "Necessity"), Artaud would say she suffered a spiritual concussion in the physical tempest. There is certainly a shocking core to these mysteries, tales of which take a person out of her "right mind": Semele is struck by lightning, the initiate is lashed with a whip. "Humanity" is sacrificed in the temporary, orgiastic eruption of "animality" when the woman puts on the dappled faun skin, wraps the snake in her hair, takes up the *thyrsus* and, in following the satyr, turns her back on civilization.

She does it because it is necessary. Like Persephone when she reaches for the narcissus flower called in the myth "the lovely toy," she is seriously toying with death. The infant Dionysos reached for one particular toy offered to him – not the golden ball or the top or the dice, but the mirror. When his image was captured, he was torn apart limb from limb and thrown into a boiling cauldron like a sacrificial lamb. Why put ourselves through this torture? Leaving civilization is clearly not safe. But neither is the safety of domesticity tolerable. The woman looks in the mirror day after day while she slowly falls apart. This is not the lovely unslackening of the limbs that "gives to pose and gesture the new beauty of abandonment" (as Jane Ellen Harrison describes the maenad released by wine from self-consciousness), but the weakening of joints; the centers cannot hold, the body is losing its connections with reality. This death comes from adaptation to convention. It is one of the first in a litany of tragedies that echo in the terrible din of the God's coming.

According to one set of myths, a woman's bondage is to her life in

the household. Duty-bound to house and husband, three sisters bury themselves in the deadly work of maintaining domestic order. When the call comes, they sit unbudging at their looms, throwing the shuttle back and forth, weaving themselves tightly into a resistance against unraveling. It is against the rules to leave, so they stay. Not only do they stay, they also mock those who follow the spiritual impulse to its source and say, in a typically unbecoming, adolescent way, "Our father is richer than yours." In other words, we have wealth enough and there is no need for us to go against convention by joining your unruly, unestablished crew.

These straight-seamed, cautious daughters of Minyas scorn the God who is essentially unstable. He is always shifting shape and arriving unexpectedly either out of nowhere or out of a previous form. The maenads call him: "O God, Beast, Mystery, come! Appear, appear, whatever thy shape or name, O Mountain Bull, Snake of the Hundred Heads, Lion of the Burning Flame!" First He appears to the daughters disguised as a maiden who warns them not to neglect the rites. When they dismiss him/her, the room suddenly bursts into a chaotic tangle of beasts and vines, a lion leaps, a bull roars, and serpents nest in baskets of wool. The women are terrified at the intrusion of unrestrained plant and animal life. This very lack of order they had so strenuously detested erupts within them as well. They are driven to kill one of their own children and then to roam the mountains like wild women wreathed with ivy, bindweed, and laurel.

Fear of departure from convention feeds these "warning stories," in which a woman's development takes a monstrous turn because of her resistance to joining the *thiasos*. Another set of three daughters attains the age of ripening but will not participate in the rites of maturity. Their bodies become covered with white splotches, and they are set out upon the hills to wander like cows in heat. Only now are they fitting partners for the God in bull form. Had they joined the Dionysian company willingly, they would have enacted this state of wild abandon within a protective circle. And they

would have emerged from it knowing what had happened. Instead they are fixated, caught in a relentless compulsion that limits their vision to the patch of wilderness where they plod, heads down most of the day, looking for mates. Naturally, "it furthers one to have somewhere to go." (*I Ching*) Hemming and hawing, as these maidens were wont to do, keeps one inside the confines of the pasture, hemmed in, run haggard.

The inability to break through the hedges of decorum can abruptly halt anyone's coming of age. Here we are talking of "mature" age. The maturity at issue in the Dionysian rites is deeply rooted in the Latin *maturus* – knowing the favorable moment for dissolving boundaries or crossing sides. This moment (pictured in the pose of "the terrified woman," Scene 4) works its way into the dream of a woman on the verge of forty: "I see the place to cross! I have come to the river from an all-night-refreshment-stand. It is a beautiful, unknown part of the Mississippi. I see the very spot, sense its importance, and am excited by the prospect, but I am stopped by a little hut of goats. I make friends with them. Two baby female kids – a cross between babies and goats. I pick them up to learn their needs. They have udders and smell of warm milk. I milk them. I figure out how to cradle them. Their changeling aspect is scary at first, but I have to make my peace with them before I can continue across the river."

Psyche dreams up so many ways of saying that we are part animal and that we had better nurse that part – or "milk it" – in order to cross over. In alchemical tradition such a creature of mixed natures was considered a *monstrum*, an immature conjunction of elements not yet ripe for melding, an awkward union of material and psychic natures. Our language is still gawky in this realm – not yet knowing how to unite these opposites – so that we utter such monstrous, immature dualisms continually: "mind and body," "spiritual and sexual," "mental and physical," etc. Images, although scary like the changeling, are less awkward and better signal the dissolution of

boundaries that occurs in the imagination. This dissolution is occurring in the frescoes at the moment the initiate hears the call of the God. She is shown standing in the forest of Pan (Scene 3), having moved away from the temple area where priestesses perform orderly ablutions. She passes through the musical portal of the old teacher Silenus (also called Bacchus) into the mythical forest. At this point, she becomes the only human figure in the drama.

Behind her the goat-eared *panisk* (female Pan figure) nurses a young kid, reminding us of a reason why the call to cross over comes to women in midlife. It is because of their intimate experience of flowing. As the disappearing girl says goodbye to her brothers, jumping into the river she will become in *Finnegans Wake*: "Why wey O wey, Ise so silly to be flowing but I no cannae stay. . . ." We get carried away to womanhood. A woman has to be on the verge of letting go in order to respond to the Dionysian uprising. The release in these phrases "letting go" and "letting one's hair down" is intrinsic to the phenomenon of the milk-filled breast, or udder, into which the milk "lets down." A woman's milk lets down and starts to flow in response to a stimulus – the actual or imagined need of a suckling other. It is an unconscious spillover. Will is not involved. If the let-down does not occur, the pressure within the breast becomes unbearable, resulting in infection and disease. The tales of punishment suggest that resistance to this urgent will-to-flow effectively settles a curse of isolation and madness on the resister. The Greeks said "the rage" would fall upon a woman when the ripening and release attendant upon maturity are denied.

Further episodes in the mythology of Dionysian women describe the bondage more specifically as being "of the body" – as if being housebound is to be bound to the body of woman. Ariadne winds her way out of the elaborate underground structure that had become her prison by tying a thread to the lintel of the labyrinth's exit door. She gives this clew to Theseus, who makes the passage, parallel to everyone's birth experience, through the tubal labyrinth

of the mother's uterine system. Every child emerges, as Theseus does from the cavernous enclosure, still holding the thread that appears to be attached to the doorway of the mother's body.

Ariadne escapes her mother only to become a mother. She, as Semele before her, dies in premature labor. This is a curious part of the myth – the point that describes women on the threshold of the *katabasis*, the ritual descent into the darkness (of birthing, of madness, of the total loss of daylight consciousness) in which they experience death without really dying. Here we are not talking about the initiation of virgins (which makes this a different Mystery than the one at Eleusis: unlike Persephone, Ariadne and Semele enter the underworld already mothers), but rather of women who are about to go under because they are about to give birth. Women in whom the fruit is seven months ripe, in whom a child is fully formed. These are "expectant" women who are already far into the process of creating some new thing, who know about the *submissio*, the "putting under" of conscious control that happens in labor when the movement from stage to stage is set by some director other than yourself.

The diligent daughters who refuse to leave their looms are caricatures of these deeper weavers who weave tissue to bone out of the substance of their bodies. They too are resistant. Even though they approach the threshold with dignity (initiate, Scene 1), they turn in terror when the thunder begins to rumble, knowing that the bull-roarer's simulation of thunder announces an inevitable bolt that will shock and sear Semele, sending her on to that final stage of transformation where what was bound inside is freed.

After the lightening (in which the uterus descends into the pelvic cavity toward the end of pregnancy) comes the rupture. There is a profound inevitability in the process of childbirth that is only like the inevitability of death. Its coming does not depend upon what one wills. Movement, despite what one wills, is a regular and disturbing characteristic of Dionysian possession. The death of those women in childbirth was induced by a shock that knocked

them out and under. The swift movement and sudden revelation (the bolt out of the blue) is like the moment of realization that the course of your immediate life is unalterable. Even though the idea of motherhood grows as slowly as the child grows, even while a woman grows slowly accustomed to the changing shape that will shape her changes in the future, she can be suddenly stunned by seeing the image of her own death in this child's birth.

The message of these dramatic frescoes is addressed to living women who know they are dying. Of death's countless faces, there are some that appear often to women in midlife. A woman entering the initiatory state steps into the place where images of these deaths are chambered, where she is caught by the stories of others that are also her own, where the moments when her life stops are framed for viewing. No detail will be missed in this strange interlude. Initiatory time is boxed, containable. Unforgettable moments in which the soul is captured, *in camera* ("in chamber"). From the entry moment on, until the lens of the room opens after the final scene, the woman moves along according to the scenario of "woman encountering Dionysos in herself": *maenadic* (mad), *thyiadic* (trembling under strong emotion), *ecstatic* (beside herself). Her first task is to listen to the fateful accounts of what happened to the women originally called to join the passionate bands of roving sisters. This reading of the situation (a forecasting) is called the *theoria* and opens the door to the initiation drama.

So it begins (Scene 1) in the life of a woman who is wanting. She does not want for a man, nor for a child. She wants to be filled like a cornucopia past the point of overflow. The issue is emptiness of the sort that grows from the inside out regardless of one's productivity, like hunger when it is for love or creative work or some other soul food. The women in this chamber carry their readiness, their open-

ness in loose gestures: their bodies appear to be relaxed, limbs flexed, hands open. Even those in extreme postures of fear and ecstasy, whose bodies are taut, wear garments that billow about the head or torso with a receptive air. The initiate in the first magnificent moment we see her entering the chamber (which is to say it three times over, to raise her entry to a higher power: "the initiate in initial moment of initiation") strikes us with her gesture.

She has stepped into the dramatic action assuming the stance of one who is ready. She wears the awareness of emptiness gracefully – holding her garments out to create an opening. With one arm akimbo and one leg bent, she looks fluid even though she stands solidly over a central axis. Her position is reminiscent of one who is about to execute the steps of a martial art in which the purpose of standing loosely centered is to be able to move easily in response to whatever comes. Thus composed, she represents the first stanza in ten movements of a ritual birth. She stands alone on the brink of this passage, as do all women everywhere who go – individually – through initiation. (Eliade, 41) Like the ova that are released one at a time to roll at lunar intervals into the receptive blood chamber, women proceed in single file. (In contrast, the collective sperm swarm of the male event is represented in the group nature of boys' initiations.) The initiate's carriage and bearing suggest her openness to, and ability to withstand, conception. This is no joke/no jest in the Dionysian realm where gestation is fatal.

She is not a young bride, as some have said, because Roman brides were adolescent. She is a woman on the threshold of descent. Entering the mystery chamber, she enters the blood chamber, the birth canal, the therapeutic passageway. She hears the stories of the initiatory drama read by a child, a small, naked, booted boy dressed

like the wild child God in his mountain habitat. His boots, the high-topped *cothurni* which will appear again on the disturbing angel in the seventh scene, suggest sacrifice in this Dionysian tradition where kids (goats) were booted at birth in preparation for ritual death. The boy reads the instructive tales of what happens to Dionysos and those who are impelled to follow him. Perhaps he follows the plot according to the playwright (the *Bacchae* was a textbook by this time, written three hundred years earlier) with fear and trembling from the point of view of the son who is too attached to his mother. From the perspective of the boy in the company of women who suffers the God's gruesome fate of dismemberment.

The seated priestess holds the other half of the story in her hands (in the rolled-up scroll). She knows the stories of Dionysos and his maddened female companions. She knows of his Cretan birthplace, the goat cave with stalagmites penetrating the space in the manner of an erect phallus entering the female space. She has heard the stories of how the great God Zeus made himself wombly to incubate the child. And of how the maenadic women stand erect as men. Having been through the initiation in which she identified with the fate of the God, both as the one who suffers and the one who inflicts suffering, she might say: "I know how it feels to be torn apart by strange desires, how it feels to tear apart the thing you love limb from limb until the parts are scattered through the wood. *Dismemberment*, however, *has this advantage, that we get to see all the parts.*" (On dismemberment and parts, see Hillman, 1980, 158 ff.)

Another one overhears. This could be the initiate herself glancing out at us as she steps into the next chapter of her passage (Scene 2). Or it is a priestess, another member of the *thiasos* who carries the plate of cut-up cakes – the reminders of the cut-up body, "the host" – to the consecrating table. Hostesses, or waitresses. These women-who-overhear, while carrying out the details of attending an initiation, are the original therapists. The next ones bring the

veiled basket (the mystery container) and the pure water (clarification) as blessings for the one who is about to go into the mythical world.

We know we are still in the place of instruction because of the scroll tucked into the tunic of the attendant to the right of the high priestess. She is wrapped like a scroll herself, carefully put together, almost studious, with her hair tied up and bound by the circlet of laurel. Like the student who "knows it in her head," her upper half is girdled by concept. But down below a significant shift occurs, according to the curve of hip and planted foot of Silenus/Bacchus. Usually heavy with wine, the old teacher, whose name means "the bubbler" or "the babbler," spans the gap between worlds. The ordered realm of the squared altar and perfectly draped bench on the hewn stone gives way to the craggy rock of the forest (Scene 3), where the instruction takes a turn toward the different order of animal nature.

Bacchus leans prophetically into this instinctual realm that fosters the embryonic Dionysian element. The woman is bodily moved off base as if by the music of this teacher who was the foster father of Dionysos. His ears (pointing to his animal affinity) are attuned to several realities simultaneously. His face (intentionally painted to look like Socrates) shares the rather feminine fullness of his body. His ample, maternal form – elsewhere covered with white dots and called *Papposilenus* or "milkgiving" – is a clue to the kind of masculinity present in this chamber. Looking ahead to the spent form of Dionysos (Scene 6) who reclines with the *thyrsus* across his lap in place of an erection, we note that pine cones like seed-bearing testicles were hidden under leaves bound at the top of the staff. We might say that here there is a masculinity proven in the saprise and the seedspill rather than in bloodshed. For example, Dionysos and Bacchus fought wars with wine and won. Theirs was a non-heroic style, a lowering of consciousness, a diffusive takeover from within.

The woman's upright body merges into the undraped bulk of an androgynous bridge. Linda Fierz-David would say that she is leav-

ing the territory of the personal unconscious via the bridge of the animus who leads away from the familiar territory of remembered things into the collective unconscious. All mortal figures vanish at this point, leaving the initiate alone to face the terrifying music. Even though Dionysos is called *Demotikos*, "of the people" (he is democratic because he "gets" everyone and is always followed in groups), he finds his way into the soul – that inner courtyard of expectation where one is gripped and swung by desire – only when it is "unattended." Only when Ariadne was completely alone, in fact stuck on the island of her abandonment, could she be approached by the God.

His call comes rumbling from off shore, from the outskirts of our nature. From Pan's place, the out-of-bounds, unknown, uncivilized pockets of our psyches – rocky places of unsure footing where we make our way by odor and feel and uninhibited touch. Dionysos is not polite. He is rather that uncivil servant of psyche, shaggy and hoofed, who shows no respect for boundaries whether they be of a person, a household, the complex lived in.

A closeup of the woman's face (Scene 4) expresses the moment of physically comprehending dread. "We can not be approached by the God, without at the same time fleeing from and seeing." Hillman's discussion of Pan locates this moment when flight becomes reflection: we go where we are afraid precisely because instinctual nature desires the very thing that makes it aware of itself. (Hillman, "Pan," xlix) Even as the woman abruptly turns and steps outside the lower border of the painting as if she will jump out of the process entirely, her eyes lead clearly to the startling scene across the hall in the far corner (Scenes 7 and 8a) where she sees herself collapsed in the lap of a priestess and being struck with the whip of the dark angel.

There is no way out now. She is stuck at the point of necessity where the soul has to go under in order to come to life again. From the outside this might look like being on the verge of "breakdown." In any case, it is a profound downer she finds herself resisting. Panic

ensues as the ground of normal life shifts. She is sucked under as if into the black subterranean passageway beneath the mystery chamber where there is no light at the end of the tunnel. Not until she gets there and turns a corner corresponding to the turn of events in the chamber above. Apprehending this scene of the painful quickening that follows the period of "wandering dead" threatens to unbalance the initiate. The angelic shock treatment returns her to the boundaries of her own body. All this forecasting would be but dimly glimpsed over the shoulder of the God (a dark stranger, or a raging bull, or a satyr, or a mad woman) coming to arouse her to her own extremities.

Objects appearing in the procession of forms around the chamber (nursing faun, phallus in the basket, *thyrsus*, the *flagellum*) support a move into the Mysteries as a move into the body of woman – ovulating, gestating, laboring, lactating, coming – a sexual move that returns the initiation to its pre-Orphic orgiastic roots in matriarchal tradition. Hélène Cixous, in the article "Come the Following Chapter," issues the reminder: "You know already: in initiation, first you believe you are losing a life in leaving your ignorance, you suffer like a woman rolling in the pains of miscarriage, at first you think you're dying in birth. So, of initiation, you know already, that its trials resemble the happenings in a body of woman." In the old Mysteries a man could enter this birthing space in a grove sacred to Ariadne on Cyprus where he would writhe in simulated labor on the day of her festival. Dionysos *Gynnis* makes men womanly. Dionysos *Dyalos*, the hybrid, crosses the sexes. His women dancing distended are phallic: turgid, tumescent, as if in possession *she into herself can come*. (Cixous, 52)

Although there are places in their work where those women write from an awareness of body and of women's physical presence to one another, Linda Fierz-David and Harding seem shy of the actual body. They would keep its acts, the physical things done, veiled. Veiling that permits seeing metaphorically is essential to the initiation process – but there are moments in the drama when we think

the veils were removed from the sacred basket, from over the erect phallus, and from the woman. The scene that turns the corner of the back wall is a disturbing case in point (Scenes 7, 8a). We do not know whether the kneeling woman is about to take the veil off the huge phallus or secure it.

Interpreters since Linda Fierz-David have looked at that scene and the one following – in which the priestess looks as if she pulls back the drapery on the woman's back in order to bare her for the blow of the angel's whip – and declared, objectively and with substantial evidence, exactly contrary opinions. One says she is about to commit the indiscretion of *revelatio phalli*. Another says she demurely covers the sacred shaft. One says the priestess hides the victim. Another says she uncovers her. Most recently, classical scholarship opines that the powerful Dionysian angel, upon whom this scene turns, is a Roman intrusion in a Greek vision and does not even "belong" in the frieze.

This question of what belongs is answered differently by classicist, archaeologist and psychologist, a point made immediately by Heinrich Fierz in the preface to his mother's work, where he makes the distinction between "reflections" and "research." Linda Fierz-David's work is reflective. She is quite aware of the research, but her aim is not to establish historical evidence of a Roman cult practice but to illuminate a coherent psychological reality that regularly admits odd and seemingly out-of-place images into its repertoire – in a meaningful way. No worker of dreams would be surprised to see a figure of a Roman centurion in as "odd" a setting as a San Francisco city council meeting. Everything fits in a composition that is crafted by psyche. Linda Fierz-David draws on the data of myth and history to discern the condition of psyche behind this series of images the way an analyst draws on that data for direction in delving a dream. Her way with the material is decidedly interpretive in that she is reading according to another text – not that of "studies in antiquity" which would rigorously refer the images to other known artifacts of similar origin, but according to the *grande idee* of analytical

psychology in the first half of the twentieth century, C. G. Jung's "text" on individuation.

Linda Fierz-David goes far in training our eyes to see through the veiled images, the "symbols." Reading for latent content in the manifest form, she constructs a *tableau vivant* of the archetypal realm in which a woman can see herself in passing. It would not be right to say that her faith in the individuation goal makes her see less clearly. Her vision is clear. And the angle is clear: she sees from the position of the analyst who has witnessed transformation. Thus when we follow Linda Fierz-David's lead, we find ourselves reading more often from the armchair position of the *Domina* seated in the southeast corner on the throne of Memory than from other points of view, for example, of the woman in the far corner crouched in "puellissime position" who bears the brunt of the passion in her body (Scene 8a). She has no recollection yet of resurrection following quickly on the heels of death.

In the transformation scene (Scene 8b), the veil becomes a ribbon of golden light around the naked dancing body. Framed in that arc of silk, the suffering woman now appears extraordinarily full – full of the spent God's regenerative energy. As the Bacchante she has taken that power into herself and now appears phallic and unveiled. Linda Fierz-David would have us see this ecstatic stretch as "entirely divine," a preparation for sublime soaring "upward to achieve union with the god." Her emphasis here is on divinity and ascension which follow the experience of the downward pull of instinct. Indeed she has stressed the necessity of taking the lower path – of going under in the ritual *katabasis* into the place of darkness, of "wandering in the bottom," characterized by depression, disorientation, and crude (sudden, unrefined, physical) takeovers of an emotional nature. Such is the maenad's place. Yet while she describes the down-going, she tempers its gravity by the frequent positing of deification, leaving us sure of the radiant conclusion, but unsure of the passage through the dark.

This position – of being in the dark about what goes on in the

dark – is appropriate to the Mysteries which nowhere tell us ex-
plicitly what events elicited the change in expression and posture
that we see, ranging from the calm self-absorption to the raw grief
and terror of the initiate. What we do see is the result of an extraor-
dinary feat of visual condensation. Multiple myths, ritual acts,
traditions and formularies are implied in the presentations of each
set of figures. It is as if our author is looking at a painting of a
lifetime, or of what goes on in an analysis, aiming for "con-
sciousness" – as if an entire case narrative were condensed into this
series of ten frames.

Her finesse in the task of keeping the material in context keeps us
aware of the goal of the central, unified Self. Such fidelity to a goal
might, in the work of a less imaginative analyst, threaten the reach
and twine of the parts. But Linda Fierz-David's example of winding
deeply into the maze of mythic associations behind each red panel
allows us to come up "lost" in reveries toward ancillary subjects.

Although the chamber invites focusing on a goal – by virtue of the
extraordinary placement of Dionysos and Ariadne at the very center
of the frieze, larger than the other figures, closer to us and out of
context of the developing drama so that each of the other scenes ap-
pears as a vignette to that dominant cluster – there is another feature
of the chamber that invites reverie, even revision. Not the kind of
revising that Heinrich Fierz warns against – because we too are con-
cerned primarily with the psychological reality conveyed by these
images – but rather a revisioning that follows imaginative associa-
tions allowing us to sidestep the goal (perhaps to even see it dif-
ferently), spending more time in the procession and in the play of
events.

The feature that suggests this to us is the intentional, technical
move, made by painters of the Villa's era, to link separate figures in
a composition by the direction of their gaze, mirroring of gestures,
and the placement of pilasters. We have considered the possibility of
the gaze connecting the *Domina* with Ariadne – though this one
case is the least certain due to the missing portion of the central

fresco. (According to medallions dated prior to this composition on which Dionysos and Ariadne sit in identical postures, their heads are set so that her gaze falls into his upraised eyes. See Bradway, 23.) The *Domina* is as likely to be looking back at the young woman in the far corner who has cast herself into the lap of a priestess. That priestess looks up at the descending angel. From across the room the fleeing woman catches this same winged vision in her wide-opened eyes. Silenus in turn looks back at her from his back wall position with the boys. One of the boys looks into a reflecting vessel. The other seems to look out at us, or is he looking shyly across the room at the woman in her final ecstasy? Sometimes the glances are direct and focused, sometimes diffuse and self-absorbed as in the closing scene of the woman's *toilette* (Scene 9). She is turned toward the opening scenes – of the entrance, the reading of the sacred text, and the consecration – but her eyes appear glazed as if she is looking inward. That her revery goes elsewhere (other than "out" of herself) is suggested by the fact that the mirror held up for her does not reflect her face. We see the face of her attendant in the mirror at such an angle that she must be seeing only the strands of golden hair that the two are weaving together.

Looking into the room this way brings the "center" out from the couple depicted *in stasis* on the back wall into a moving midpoint in the chamber where lines of vision actively intersect. There is *no thing* at this center point (except in the relevant speculation of the writer who thought an open *pithos* stood in the center of the room exuding the fragrant, intoxicating, sense-mingling vapors of the wine). Glances intersect and images mirror each other at this invisible juncture. Clusters of figures on one wall appear reversed in the composition opposite. For example, the pattern of the maiden seated openly facing us flanked by two shorter male attendants is reversed on the opposite wall where the officiating matron sits with her back to us flanked by taller attending maidens. The reversals of sex, position, and intention (one revealing, one concealing) effectively set the room into a motion that is carried further by the con-

tinuous, undulating pattern of figures standing and seated. If you follow the rising and falling heights of the figures around the room, it becomes apparent that there is a pattern of visual crescendo and decrescendo marked by pilasters like bar lines. (See, for example, Scene 8a, b in which the measure of excitement runs the visual line from the initiate's foot in the lower left corner up her back, up the veil, up the other woman's arm, and overhead to the raised clash of the timbrels.)

Our impression then is that there is no "goal" apart from the recognition of where one is in this continuous process of arriving. To be sure, there is directional purpose in the pattern of the chamber that circles the passage from maidenhood to maturity. But the movement subsides (settles, seats itself) in the reflective pose of the woman whose eyes seek the invisible shifting core of the Mystery. And the core is not simply the couple enthroned in *con-iunctio*, but the complicated recognition of the woman's identity with and difference from that emblem of wholeness.

When we revise this way, according to the pull of recognition and the lead of the image, trying to see the drama of our lives as women *sub specie Dionysi* (under the aspect of, or to look at from, Dionysian perspective), we are inevitably drawn to a place where what we have lived comes back to us. We do not experience the end of a rite of passage as a conclusion but as a place of stretching and of re-entry – even into confusion ("Come the Following Chapter"). Though when the confusion is familiar, when it reminds us of one of the vignettes in this chamber already lived – we tend to see more.

If we had to identify the image at the heart of this psychological initiation process, we would hold up a two-way mirror, or perhaps an eye, a camera, or a *speculum* which is a mirror but also an instrument for rendering a hidden part accessible to observation: it is a peculiarly feminine mirror that can reflect back a woman's inner-most parts. Linda Fierz-David holds up the image of the sacred marriage of Dionysos and Ariadne – the object of our specula-tions – as central. This gesture makes us think of Jung holding out

the lotus blossom, the mandala as central. And of Freud, talk-
ing with H.D., holding up Niké who had "lost her spear":

"This is my favorite", [Freud] said. He held the object toward me. I took
it in my hand. It was a little bronze statue, helmeted, clothed to the foot
in carved robe with the upper incised chiton or peplum. One hand was ex-
tended as if holding a staff or rod. "She is perfect", he said, *"only she has lost
her spear"*. I did not say anything. He knew that I loved Greece. . . . I
stood looking at Pallas Athené, she whose winged attribute was Niké, Vic-
tory, or she stood wingless, Niké A-pteros in the old days. . . . She has lost
her spear . . . that would become here after a pennant, a standard, a *sign*
again, to indicate a direction. . . . (H.D., 1974, 68)

Often, when following the signs as the analyst sees them, we are
led to the finish of a case as if to the resolution of an elaborate plot.
We have all read those narratives that arrive at the *punct*, impres-
sively concluded as if according to an inherent teleology. Like
Apollo who punctuates his pursuit of the nymph with his final
grasp, there is a form of analysis (not Dionysian) that would
sentence the patient to a conclusion, "with closure," *claudere*
"shut," with *clavicula*, "little keys to the chamber," the *caisse* in
point. Once accustomed to the interpretive turns that would lock
an image into a niche, it is easy to forget to pause, to wonder at the
complexity or the pain of what happens in stations along the way.
Or worse, we become caught in the pause, feeling desperately in-
adequate, knowing that we are stuck somewhere "between an in-
itiation and a terminus I cannot name" (R. Duncan) – without the
same faith that buoys the analyst-come-to-conclusion.
 We wonder as we read whether such analytical clarity is related to
being "above the body," like Ariadne whose name means "utterly
clear" when she ascends in the crystal-cold Naxos dawn to become a
starry crown in the heavens. Individuation imagines an end in sight.
It aims to arrive at a crowning via the transcendent function – an
ultimate constellation of consciousness. Initiation ritual has a

similar purpose in its practice of "enthroning" that exalts individual participants at the moment of their representing, or standing for, God (Scene 6). But the crowning that follows the enthroning is also a sign of the body's birth—as when the child's head is said "to crown" at the moment it first becomes visible in the mother's vulva. The initiate leaves her primary matrix to come into another one. The moment of arrival is warm and red and close. It is profoundly felt rather than understood. The site of sudden, numberless openings onto a different world.

Looking at initiatory birth this way fits with the *other* ending of Ariadne's story in which she goes down instead of up. She dies pregnant and falls into the embrace of the underworld where she gives birth to wine, the fruit of the vine that also "clarifies." This clarity results from burial in the mothering earth. In heavy, porous jars stored underground, the red (or "purple" or "gold") liquid goes through the process of separation and differentiation. The sediment falls through the gloom to the bottom, and the "spirits" come clear. In the course of time the matter settles, the whole resolves into its parts. When the wine was drawn up on the birthday of Dionysos—full-bodied, dark and clear—the bottom dregs were carefully collected for painting the faces of mimes. (Kerényi, 336) Clarity arrived at this way is associated with the body that acts. We come to understand through the body's actions. In imitating the birth passage the initiate is reborn.

Cixous (49-53) looks into the chamber from the bottom (Scene 8a), an angle complementary to Linda Fierz-David's overview *Domina* position. She names the *Domina* alternately Antouylia and Pouvoir-de-la-Chaleur-á-Vue (Force of Warmth Seen). Crouching motionless, contemplative "in the northeast corner of the room, as I in the puella position crouched in the chamber," she faces Antouylia "seated in the armchair southwest in the *domina* position, heavily weighted in herself, domina gravida." Heavy, entirely thinking, restrained, absorbed, calm—waiting. The *Domina* waits as if she's been awaiting your arrival two thousand years.

Cixous draws the reader into the candidate's corner. Not-yet-initiated, or not-yet-arrived, the puella is still the young female facing into the mysterious pull of a woman's body. In contrast to other writers who view the room with a detached eye, coolly, Cixous sees red and warm. Her puella's vision is colored by the warmth emanating from the body of the woman who has arrived: "you are held motionless and distant from her but in view of her body and yet you feel the warmness of her vitality, you feel the eyes and from afar, the warmth mounts in your eyes." This warmth does not signify arrival, but arousal. The initiation has begun.

She does not make the simple equation: initiation means new birth. Instead, she counters the psychoanalytic habit of speaking from the dominant position of consciousness, where such equations are made, and writes from the pre-articulate verge of being born where what is known is what is felt. ". . . you feeling the warmness of that [of the beginning], before you know what that is, feeling that that is of a warmth little elevated, constant, sweet, as the warmth of the maternal voice around an infant in the water of the womb." Then she deftly transposes the original scene of birth into the scene of initiatory birth where "you are unaware and you know it."

The difference between being born and the births occurring later in life is the awareness of your ignorance – that you know you cannot know what is coming. The transposition in the chamber permits us to see the secret dawning. A woman is about to see the unseeable, to see herself born. "If the view of Antouylia, seated in herself, makes you warm, it is because she contains a mystery in activity. . . ." Labor has begun. Cixous attends the birth as if attending a death, knowing that in this passage the present person dies. Her injunctions to "advance and go!" are spaced in the text exactly the way the midwife's "push!" punctuates the air of the birthing room:

– In initiation things are communicated directly from one body to another body by every sense united, atmospherically, and sheltered from all

thinking . . .
– Go, and advance into it (initiation)!
. .
– Advance and go! . .

<div style="text-align:center">The mystery is always of a body . . .</div>

. .
– Advance, advance, in the burning warmness of ignorance almost van-
ished from anguish, advance and suffer, advance hardly vanished in ig-
norance, advance and approach almost dying in ignorance almost dead,
approach in the death agony of approaching, advance before you, from the
left side, your eyelids contracted over your eyes in order for you to draw
near the mystery, eyes carefully veiled, view turned towards the sole secret,
approach in suffering, as the infant transported outside the womb during
its proper gestation, attending prenatally the mysteries of maternity,

. .
. . . – In initiation, there are these three days of daylight reigning in the
cloister *domus hymenaia aurea*: it is red-purple and red-rose and ebony black
shining among reds.
The initiation is warm and dry.

<div style="text-align:center">The mystery is always of the body.</div>

<div style="text-align:center">The mystery is always of the body of a woman.</div>

– Approach Antouylia, now, she arriving in herself, seated into herself in
the red room, like a woman awaiting a woman two thousand years, she as
a woman full of wisdom awaiting a woman still ever void and light and not
yet happening to arrive in understanding herself, and now, you bent over
her, open your eyes and lean lightly over all of her body, arrive and listen:
– And from the bottom of her body she makes you know: Listen puella.
<div style="text-align:center">The mystery is woman. The mystery is always
of a woman.</div>

The mystery of the mystery is being woman.

Listen from the bottom of your
body and know:

The mystery to be a woman is: only one, a single
woman, is not alone: the mystery is
always of the body in the body of a woman.

(49-53)

Reading this red-walled chamber with Cixous – who nowhere explicitly locates herself here yet describes precisely the interior of the Villa standing outside of Pompeii – we enter our own bodies and the body of every woman ever "known." Woman arrives to woman, eyes veiled, arms open, merging into a body of knowledge that she calls vegetal rather than carnal. Her Antouylia (partially understood as *en tout il y a* or "inside-all-there-is") quickens, enlivens (*vegetare*), arouses (*vegere*), and draws the initiate to the bottom of the mystery which is this – that woman gives birth to woman (herself).

In Antouylia, the separate functions of the priestesses, which correspond in Linda Fierz-David's vision to the analyst's roles, are incorporated in one feminine form. Going around the room, she is the scroll holder, educator, instructor (Scene 1) who imparts the *theoria*. Then she is the one who consecrates. Sitting with her back to us (Scene 2) at the altar with wicker baskets, she shows us that mundane items in nature and the household carry sacred weight. Next she appears in the scene of Cixous's crouching *puella*, the scene of the initiate's remorse (Scene 8a), comforting her at a distance without interfering with her overwhelming feeling. Then she appears in an analytical role as the one who is aware of the mirror while the initiate's hair (her "thoughts") is being rearranged for her reentry into the world (Scene 9). And finally she is there in the *Domina* of ample maternal body (Scene 10) who sits on the high

couch at the far end of the chamber looking back at the plot unfolding.

Perhaps it is the maternal nature of the analyst in Linda Fierz-David's approach – for she writes artfully from each of these perspectives in turn – that does not want us to wander long in the dark phase of abandon (no goal in sight) that corresponds to the activity on the back wall going on under and around Dionysos and Ariadne. Before entering the *katabasis* portion of her work, we are sheathed with the prophylactic assurance "nothing degrading will happen in this place." Nonetheless, our questions are huge: What, for example, becomes of the body? Doesn't *degrade* mean "going down"? What is the significance of the phallus in the woman's ritual descent? Is the disclosure of the potency of Dionysos "only spiritual," "merely metaphoric"? Will she take him in both hands when love is ripe, beyond bearing, and wants to go to seed? And, above all, is there holy purpose – *must* there be holy purpose in this sexual scene?

Growing up with a parental emphasis on the spiritual nature of sexuality had odd consequences for many girls who have long since been overheard to ask of their partners on the brink of sex: "Do you believe in God?" We were led by the respected arrow of sublimation into a variety of passionate situations with teachers or poets or preachers, "men of meaning" (and sometimes women), whose noetic lust aroused us to extraordinary heights. Our interest in sex was "pure." It had the goal not only of union but also of elevation. Sex would raise us – not deepen, darken, and convolute. There was a peculiar onesidedness in being raised that way, a onesidedness that is evident in the statement of the Jungian text in which Linda Fierz-David's disclosure of the Dionysian secret – that sex is holy – is followed by the warning that "this secret must remain strictly hidden because of the danger of degrading the ultimately valuable." Thus we are permitted to feel sexual enthusiasm in deification (in becoming one with the God), but we cannot see the God in

primitive, ecstatic, instinctual sex which has no "ultimate" purpose. Such "attacks" of blind abandonment to nature are "cata-strophic" – according to Harding (in her introduction to the Villa book), who does not see Dionysos lurking within the repression of her sentence.

What we were not told as girls, and what Harding does not tell us now, was that abandonment to the body's desire is in itself a source of revelation. There is a harshness to the morality of her preface written in 1960 that belies her complicated, sensual (and now classic) psychology of virginity written in the 1930s, in which she saw the great wanton Goddesses as self-contained, belonging to no man – even *promiscuous*, especially in its sense of being "in favor of mixing." Esther Harding's early work led to seeing that the way a woman was sexual told what archetypal constellation she was in: turning her back on the man in bed like Isis gone to the Nether-world, prostituting like Aphrodite, wounding and pursuing like Psyche. According to this way of seeing, a woman would be work-ing out her fate under the sign of Dionysos if she suffered the periodic abandon of a maenad – leaving her senses, leaving her home for the wild congress over the hill.

What comes down to us in the generation following is a catalogue of fears that seems almost to vie in weight with the volumes of in-sight. As if the rumbling collective voice of those women that so roused us in our youth would restrain us now in later years in the effort to locate the sites of our own rites of maturity. It is not what we know of their lives that stops us – the astonishing stories of their dedication to work, their love of companions in the quest, and their commitment to the reality of the psyche – their example does not stop us, but rather the appended moral and the inclination to warn.

Certain warnings often repeated in the Jungian literature of Harding's era converge in her preface and in Fierz-David's text fol-lowing. For example, that it is dangerous to work with unconscious material without a guide; it is dangerous to pursue an interest in a

spiritual tradition other than the one in which you are culturally rooted; auto-eroticism is dangerous; pride and inflation are disastrous; plunging into instinct for any reason other than renewal leads to destruction; groups have large conglomerate shadows and foster predictably inferior behavior.

In this manner Linda Fierz-David decries the orgiastic nature of late Dionysian religious practices (I say "late" in order to refer to the stereotyped Roman bacchanal that she must mean rather than the earlier *orgia* that were collectively experienced devotions). Her insistence makes us curious when she says: "We can say with the greatest assurance that life in the Villa cannot have been orgiastic." Orgiastic wantonness, because it is considered dangerous to the individuating soul, has no place in the process – even though wantonness, insofar as it is rooted in "wanting," "vacancy," "waning" (as in "waning hope"), is essentially a pre-initiatory condition. We could even say that when a woman locates this feeling in herself she has come to the threshold of the Mystery event. Wanton also implies ill-breeding and a poor education, and it was for this reason, we remind ourselves, that Harding found initiation necessary as "education of the emotional life."

There is a familiar ring to reading the string of dangers. It is not the voice of the preacher exactly, but it is a voice concerned with morals. A language of right conduct runs right alongside the daring discussion of rushing into the darkness with only instinct as guide as if Athene, or some other Goddess of noble breeding, would not let the maenad out of sight. This language channels the reader with weighted words that threaten to tilt the message of the text – especially the introduction – toward a prudery that detracts from its prowess. These words: pure, impure, disaster, treachery, danger, self-control, moral, immoral – the cautionary vocabulary employed by some in psychological circles at the beginning of the century (implying judgment as did their colleagues in anthropology who distinguished between "civilized" and "savage" men) – remind us of

another source, a secret source of information that gathered dust in our grandmother's basement next to her copy of the *Bacchae* from sophomore Greek Civilization, 1899.

Such as it was, this source was of sexual knowledge, a series of pamphlets with intriguing titles: "Instructing Your Child in the Facts of Sex," "On Guard," "Some Things a Girl Should Know about Her Health" – all written circa 1919 in Columbus, Ohio. In their time they were daring to insist on talking openly, to insist on frank disclosure. These pamphlets were evidence of the post-Victorian (and post-war) movement to admit the body back into being: "Until recently there has been silence and secrecy in matters of sex so that women and girls have not known the close connection between the proper care and use of the sex organs and general health; and the connection between their own health and the health of future generations." The gist of it was that the future depended upon frequent baths, the wearing of proper clothing that would not irritate the external sex organs, correct posture, and the willful control of the sex impulse which, "when misused, brings disaster." And in a concluding sentence which seems an echo of Dr. Harding: if "directed and controlled the sex instinct is the basis of the renewal of life."

Persons of high standing – the privileged, civilized, responsible ones – demonstrated the virtues of mastery over impulse, that instinctual sublimation of which Freud found women "little capable." Is it our imagination that those women then rose up immediately upon the fleeting heels of his pronouncement? Those women who astonished us by rivaling the works of the fathers not only in parallel modes – papers, theories, scientific bulletins, monographs – but in asides: poems, journals, art, memoirs. When Freud lectured to H.D. on his theory of phallic supremacy, for example – only weeks into her analysis with him in 1933 – she rivaled it, not aloud at that time, but in her memory recorded in "Advent" of the tough cactus strip given to her by the old gardener. She describes how the fibrous stub began to glow and how it miraculously (for he had his plant

"for years and not a sign of blossom") burst into flower. A huge red flower like a water lily with petals "smooth and cold, though they should have been blazing." (1974, 126)

Our Maine guide was not quite accurate when he suggested that all those women needed was a man. Like the gardener who gave H.D. the cactus stub and Freud who wanted Niké to have a spear, he supposed something essential was missing. The women in Jung's circle might have responded in the language of their day that "a creative encounter with the masculine principle" sufficed. In other words, they had what they needed. Nothing was missing for the women who had found their métier doing analytical work or for the *Jungfrauen* who sat as scribes, attentive to every word of the teacher, every move of the great bull in the pen. (For Jung is said to have said once in a classroom: "I am the bull in this pen.") Did those women call that out of him like their foresisters at the College of Elis who roused the bull-Dionysos to come charging in springtime? Or like Jane Ellen Harrison who elicited such a response from Bertrand Russell when she lectured on the *Omophagia* and the Wild Bull; she said he made her "the sporting offer to 'stand' a wild bull, if I would rend it limb from limb." (Stewart, 26)

Relationships with the masculine – a man, a principle, a God – are quite relevant in this company of women. Even though their *thiasoi* are exclusively feminine, they require the encounter with the other that arrives to them *as if* from someplace beyond their ken. Sometimes this place is described as spiritual, sometimes sexual. Sometimes actual, sometimes imaginal. We are encouraged by Fierz-David's analysis – in a traditional move that grates disturbingly on our current ear for gender awareness – to foster relationships with men who are philosophers and spiritual teachers because of their "inherent consciousness." But when it comes down to the sexual crux of the Mysteries, the emphasis shifts from requiring a man to requiring a less graspable "principle."

The transparency of the veil fluttering down over the presentation of the God's erection permits us to look more closely at the role of

this virile member in women's initiatory transits (Scene 7). It does point upward as befits the religious function of phallus symbolically indicating the uplifting, procreative masculine presence. And it is surely rooted in the female basket, the *kista* (or "box") which in Greek drama served as an intentional pun on the *kustos* or "cunt." Can we not approach this conjunction in "a deeply religious spirit," as Harding enjoins, and still school ourselves to scan in more fluid fashion, also appropriate to the Mysteries, to look the phallus up and down its full important measure from euphemism to obscenity? Obscenities, which momentarily strip the adult mind of its distancing powers, are valuable as primary movers. Such offenses to dignity had their place in theater, and in mystery dramas; they should as well in modern psychotherapy according to Sandor Ferenczi, who thought both analysts and patients should speak of sexual matters with obscene words precisely because of the ripple effect that excites feeling. (Jeffrey Henderson, 36)

Linda Fierz-David's scholarly interest in things Dionysian seems more open to suggestive scanning than Esther Harding's introductory plea for decency allows. (The closer we come to seeing who those women "really" were, the more we are forced to admit there was hardly uniformity in their ranks.) A detectable strain of interest emerges – humorous, sophisticated, fluent – in her commentary *The Dream of Poliphilo,* where she follows a rivulet of "the peculiar sap of Dionysos," the *vinum ardens,* into the heart of a Bacchanalian procession. Her observations of the protagonist – who encounters the sensual, emotional, savage, and mad reality of the South "like a grave Northerner" – lead to an analysis of the author whose psychological type is remarkably similar to her own. Of him she says: "His supreme gift is intuition, that is why he moves with such ease in the world of dreams. Further, he has the extremely active mind which marks him as a humanist scholar. But his capacity for feeling has remained backward. . . ." The Renaissance monk is akin to the analytical psychologist. Both have "remarkable intelligence equaled by their intuition."

Her son said of her that her feeling was not very clear, and sensation poor. Thus the inferior function becomes the way of departure. She sees this with crystal clarity for the monk who can only come to know reality by plunging into the very root of his entanglement:

Thus he only comes to know reality by plunging into the unconscious. Sensation is for him the point at which he remains entangled . . . he feels worthless and weak, while a chaotic savagery stirs in him like the bacchic frenzy of the ancient mysteries. That is why his inferiority is repulsive to him; he dreads it too, for it removes him from his ordinary consciousness and thus awakens in him the fear of madness. (Fierz-David, 1987, 117)

Next we see the old maenad trailing the procession through Poliphilo's eyes – or rather through Linda Fierz-David's as his twentieth-century interpreter. The ferocious virago shakes her basket with wild laughter. Dancing, lewd, demented, she ripples with the sensuality of the fountain of Narcissus that the monk is required to dip into for the purpose of "correcting the fine strut of the humanist." Fierz-David is well aware – and tells us – that the devout scholars who idealize classical antiquity inevitably come to grief on its lasciviousness. Their shock is similar to that of discovering the garish colors under the dazzling purity of "white" classical sculpture. Or the discovery of a wild maenad in the place where your dignified mother had been.

There is not the slightest whisper of the lascivious virago in the elegant, remembered form of Linda Fierz-David. But there is a small clue for us to pick up in the tale told about the time the family dog took on the inferior sensation problem. According to Heinrich Fierz, his mother "introduced a rather distant attitude in the family." They were not speaking much to each other when one day the cairn terrier suddenly had a fit. He ran in circles in the garden, went completely mad. The third son then had a dream that theirs was "an English family." He thought that was not as it should be,

and it was decided to be more open. "The fits of the dog stopped and Mama began to see analysands under the supervision of Jung." Her first intellectual project shortly after that event, at the age of forty-nine, was the psychology of primitives.

Sensual? Emotional? Savage? Mad? Did she embody these qualities of life from the land south of the border, the qualities she lists as critical to the redressing of psychological imbalance in the questing scholar? Having been led to ask of those who knew her, "Was she Dionysian?", I am now familiar with the response: "If she had a Dionysian strain, it was certainly hidden." It could have been well hidden under the subtle cloak of Orpheus, a figure whose cult increasingly drew her attention.

Other devotees of Dionysos had certainly been wooed by the charming air of Orpheus. In fact, Jane Ellen Harrison wrote three major chapters about him in her lengthy *Prolegomena*, detailing exquisitely the ecstasies of being his initiate. In a reflective paragraph that is set apart from her main text by a solid black line, oddly reminiscent of Fierz-David's spacing move mentioned above, she writes of the transformation possibilities in the *vinum ardens*. It was while composing this piece for the public that she wrote to a friend in private, "I am so fond of Orpheus I find it is almost indecent to write about him." (Stewart, 26)

Those to whom wine brings no inspiration, no moments of sudden illumination, of wider and deeper insight, of larger human charity and understanding, find it hard to realize what to others of other temperament is so natural, so elemental, so beautiful – the constant shift from physical to spiritual that is the essence of the religion of Dionysos. But there are those also, and they are saintly souls, who know it all to the full, know the exhilaration of wine, know what it is to be drunken with the physical beauty of a flower or a sunset, with the sensuous imagery of words, with the strong wine of a new idea, with the magic of another's personality, yet having known, turn away with steadfast eyes, disallowing the madness not only of Bromios but of the Muses and Aphrodite. Such have their inward

ecstasy of the ascetic, but they revel with another Lord, and he is Orpheus!
(Harrison, 453)

The veil around Linda Fierz-David's conclusive utterance that
"sex is holy" strikes us as more Orphic than Dionysian. It seems to
cover almost too well the shocking core to these mysteries. Jungian
analysts since Linda Fierz-David who have used this material have,
for the most part, stuck to the individuation parallel with its
spiritual aim and have not dwelt in the murkier realm of Dionysian
turbulence, full as it is of erotic compulsion, hysteria, obsession,
possession, and what modern psychiatry calls "substance use
disorders" or drunkenness. The Orphic attitude would tend to see
the fashioning of the soul occurring in these pathologies
developmentally as steps toward a more pure existence. Orphism
buries the old Dionysos alive. But, in so doing, keeps him alive.

The analyst Joseph Henderson reviews this phenomenon sum-
marily in *Man and His Symbols*. (142) His debt to Jane Ellen Har-
rison in these paragraphs is not coincidental but rather evidence of a
kinship link through affinity. (It could be said that he inherits an at-
traction to her through marriage owing to the fact that his father-in-
law was Francis Cornford who wrote the luminous tribute, quoted
above, to the "priestess" of Cambridge.) He notes the wild origins
of the rites that initiated novices into the closely guarded secrets of
nature. He describes the use of wine as initiating agent to produce
the symbolic lowering of consciousness necessary for the opening of
the initiate to the erotic enactment of Dionysos meeting/mating
Ariadne. In time, the emotive fullness of the rituals waned, and
there emerged a longing for liberation from the drastically shifting
ground of the Dionysian experience. Then, in an echo of Harrison,
he says that an asceticism developed in response to the extravagant
physical tempest, and the impulse to ecstasy turned inward in the
worship of Orpheus. "Though sublimated into a mystical form, the
Orphic mysteries kept alive the old Dionysiac religion."

If analytical psychology has in its past been characteristically "Or-

phic"–veiling the body with metaphor, upholding the ecstasy inwardly contained, appealing to mystics (whether or not it was itself "mystical"), aiming for spiritual transformation through symbolic initiation – the "Dionysian" undercurrent has been kept alive under the surface. Less manageable, tending to burst and roar (as *Bromios* the Thunderer), the energy of the uncontainable enthusiasm sweeps suggestively through the literature by and about those in the company of Jung. The special gathering of women, such a peculiarly Dionysian trait, has long been noted. Recently, van der Post in *Jung and the Story of Our Time* described "the numbers of truly remarkable women who rallied around Jung"–including in this particular register his wife Emma, his companion Toni Wolff, his friends and colleagues Marie-Louise von Franz, Barbara Hannah, Jolande Jacobi, Cornelia Brunner, Olga Fröbe-Kapteyn of Eranos, and Linda Fierz-David, whom he calls "that aristocrat of spirit." (230)

Light-years before he could have imagined his way in and among this gathering of women who would come to see the cloaked, hermetic "guide of souls" in him, the boy Jung seriously toyed with an image of himself that was phallic and veiled – and in keeping with the pre-Orphic pattern of the world according to Dionysos. At ten, he carved a little wooden man that he wrapped in a cloak and kept hidden in his pencil box. He secreted himself as if in the *kista*, the basket that hid the sacred carved object.

The initiates who first bear the baskets in our chamber do not seem at first to know the significance of what they carry. They present themselves quietly, with dignity. Easily "spiritual aristocrats," they are like maenads of a noble house before the storm. We can imagine them standing straight enough to gracefully balance the basket on their heads, as Zeus instructed the great mother Rhea to do when the one missing part of the dismembered God was found. She put the vital, still-throbbing representative fragment of the God in a *kista* and carried it on her head nine months to term. Some say it was the phallus, some say it was the heart. In any case, she bore

the God-given core of the Mysteries on her balanced head and re-issued the whole child Dionysos.

It is not difficult to see those women in this role vis-à-vis Jung, as eminently capable of head births. But we know now to turn the cup to see more of the picture. On the other side of the dignified matron (who you will recall is going out to see something in the night, is meditative, reflective, aroused to "study") runs the un-tamed one taken madly by spirit. For her, the call of the God leads down into the groveling dark. Directly into the Dionysian vein that snakes its way under the back wall of the frescoes.

In the chamber we notice that all the women's activity goes elsewhere after Scene 4. Just as the initiate reaches the corner of an-ticipation where she desperately seeks to divine the scenes of the coming passage, she disappears. She has gone under, or out, "out like a light." According to early speculations of an outside observer, the fantasy of the multitudes followed the representative woman out of the chamber and into an underground corridor where all lights were extinguished. In the black-out she suffered the tortuous encounter that eventually led to crowning. When Fierz-David in-sists that no one ever sees this essential moment as it happens, with the exception of the *Domina* who looks back with the eye of memory, she is telling us as much about analysis as she is about in-itiation.

Scenes 5 and 6 are the ellipses that characterize the process – the critical omissions, leaps, and lapses during which the action con-tinues to stir unseen. The proprioceptive poet Charles Olson would open a line of poetry with a bracket that never closed. Thus drawing the reader into an enclosure that was open-ended the way a boat is drawn into locks that lower to another level of water. Rather than return you to where you were before starting into the line (which a closing bracket would do), he continues lowering you by steps into the current where the next line or image appears somewhere downstream. In Scene 4 the initiate poses like a single bracket in relation to the elliptical dash that follows. Her sentence to descent

might have been one of the first in Orphic creed: "I have passed with eager feet to the circle desired, I have sunk beneath the bosom of the Underworld" – into the sub-chamber, the bridal chamber cum birth chamber.

In analysis there is always something happening in the sub-chamber. Jung found his way into it by developing (according to Heinrich Fierz) "a specific art of the mild lapse of consciousness." He would sink into another level, as if into the *katabasis* with the patient, then suddenly come up somewhere else intent and focused. Another senior analyst described the sub-plot of an analysis as if there were a room beneath the consulting room. He could see through a plexiglass cover into the sunken chamber where the position of the couple entwined reflected his immediate relationship to the patient.

The women in Jung's first-generation circle did not speak openly about erotic transference and counter-transference in words that filter down to us. But the images that survive them – the ones they chose to amplify in their life's work – do speak. It is extremely significant that this series of frescoes boasts no men. The phallic presence is absolutely central, but there are no mortal men present. Only male figures that people the imagination: a paunchy satyr, pointy-eared Pan boys, and the God who, as Lord of Women, belongs wholly to them. (One small mortal boy is central to the opening scene, and he is shown "standing in the God's shoes.") The male figures who occupy transitional places in the first half of the passage disappear completely in the final scenes when the woman (newborn) is returned to herself.

It is a way of saying that maleness has a critical intrapsychic role in a woman's passage. Or, more specifically, that a woman is pulled beyond herself (seduced, educed: seduction as a form of education) by the masculine qualities of *Silenus* the fatherly teacher, *Bromios* who abruptly and loudly calls, *Lysios* who loosens, *Penes* who penetrates, and *Sabazios* the breaker in pieces – all guises of the God, as well as descriptions of what happens in the course of an analytical

relationship occurring in this constellation of Orpheus the En-
chanter. It does not matter whether the analyst is male or female.
(And this relationship is not the only sort privy to transference.)
What matters is the nature of the archetypal insistence. If there is a
strong Dionysian undertow, then the work will be moved by the
maddening desire to be filled not only to the point of overflow, as
mentioned above with reference to the entry scene, but to the
point of breaking. "Open is broken," as N. O. Brown said of Love's
body; "there is no breakthrough without breakage."

One of those women who describes herself as "probably the last
person alive from the early circle" in Zürich (Tina Keller) gives a rare
rendering of such a possession. While working with Jung in 1915, she
met an inner figure of "the dark doctor." He was a towering, black
healer – both terrifying and arousing – whose power increased in her
to the breaking point. Leonard, as he was called, told her with the
insistence of *Bromios* that she had to open her mouth. She told him
that if she did it would just be a howl, it would be the groaning of
animals: "I walked about for one week in terror constantly hearing
this strange request to open my mouth, and in imagination I heard
a roar of a bull." (290)

This mesmerizing man first appeared in her husband's study, sit-
ting in the carved armchair as if to show her that he was an alternate
source of knowledge. She craved answers that were not bound in
the philosophical theology spoken by the pastor she had married.
Leonard opened doors into unexpected caves of insanity,
underground sewage systems, stores of anxiety. He was an initiator
for her, a guardian of the threshold, who insisted she live in the ex-
cruciating cracks of the *katabasis* even as she ran a demanding
household, raised children, and went about her studies.

It happened that Tina Keller's name was in the air of my child-

hood home, not because of her receptivity to the black bull's roar, but because she was the wife of an unusual Swiss clergyman who had studied with Freud, Bleuler, and Jung and was a friend of the grandfather who had inspired in us the notion of vocation as calling. What we overheard about her ("remarkable, hospitable, five children, studied medicine") was beside the point of the impressions gathered, that she was graceful, intelligent, daring, and grand.

There were others in this near-mythic category who sat on shelves in the background – the way they do in any family's history, exuding their subtle influence. Bindings of great-aunts, like Frances Wickes and Ruth Olyphant, marched across this shelf in a company of literary familiars. Olyphant (the one who wore jodhpurs and taught at the YWCA) wrote a disguised psychological memoir, "Thanks to Analysis." Her story impressed me as being from another planet, if not another era. When she was a young woman, "the dragon of melancholia had her by the throat." She suffered for months at a time from a slightly elevated temperature and was kept in a room attended by her mother and rarely permitted to venture outdoors – at the age of twenty-one. The first time she tried therapy, the doctor took her on his lap and she fainted. Soon after, she caught the rustle of a rumor of psychoanalysis in the air and started bravely off to Europe on her Quest.

Despite their singularity, those women circling the periphery of ordinary life blurred into each other, creating a composite portrait of the accomplished, post-Victorian woman who took on the exploration of the soul as if she were on safari. We attributed tremendous courage to her because she was independent. At a time when leaving home began to generate in us anxious excitement, the independent woman in our imagination appeared as a reminder that all things were possible. Nothing in the composite portrait indicated any acquaintance with the sordid things Leonard pulled out of his stovepipe hat in Dr. Keller's study – as if he were reaching through a toilet into the foul sewer. There were no black holes in the image. No hint of tragedy, failure, ugliness, or breakdowns. It

took years of attention to life to tease these other dimensions out of her idealized form.

Many guides conspired in this task of gradually altering the picture, but the best-equipped for training the imagination to recognize the complexity within that image simplified through glorification appeared to be the poet. Especially one who understood her imagery as a veil over deeper disclosure.

> now take the basket,
> think;
> think of the moment you count
> most foul in your life;
>
> conjure it,
> supplicate,
> pray to it;
> your face is bleak, you retract,
> you dare not remember it: . . .
>
> *What they did,*
> *they did for Dionysos,*
> *for ecstasy's sake*:
>
> Now take the basket –
> (ah . . . can you wonder
> that my hands shake,
> that my knees tremble,
> I a mortal, set in the goddess' place?)
>
> (H.D., "At Eleusis," 1983)

Dramatic images of breakdown occur regularly in H.D.'s writing. She felt impelled to trace the cracks in her psyche, and at the same time in the psyche of the world at war. The fire and ashes that destroyed Pompeii burst out again over London in the bombs of

the Blitzkrieg, the "lightning war" flashing through the dark scenes of *Bid Me to Live* (her story of the end of her marriage to Richard Aldington, first meeting D. H. Lawrence, and the company of their friends). "It had all happened before/It would happen again." H.D. was an initiate. History was for her the Mystery. D. H. Lawrence was the pointy-eared man who came to lead her away. "Kick over your tiresome house of life," he said. And "Leave your frozen altars."

She describes him at an early meeting when they were left alone in order to commence an affair. (It happened that the fire between them shied away from the body and lit in the brain as cerebral inspiration.) Lawrence sat in front of a decorative screen. He was telling an amusing story about flattering the landlady on the stairs the night before. As he talked he threw back his head laughing, whereupon H.D. suddenly saw a carved mask clapped on his face. She knew that she had seen it somewhere. "It was the Ruben's red of his beard, or Titian. The mouth (now that he laughed like that) made him Satyr. There, suddenly in a second, he was stamped on her mind, the flame of the red beard, aggressive, horn-symbol, horn of plenty.... The eyes were wrinkled with laughter, the eyes were drawn slant-wise up toward the ears. He was volcanic; sun baked pottery would make a mask of this, painted of course." (1960, 84) Now he was a satyr in her garden. Soon he would be Orpheus. There would be a light around them like sheet lightning.

H.D.'s husband did not take the correspondence she kept with D. H. Lawrence lightly. She said the letters between them were the kind you could toss to your husband across the breakfast table. Perhaps Aldington couldn't detect the precise degree of charge in "the uneven lightning of her lines" reaching long and short across the paper – this was the sheet lightning – but she had been struck, and that he could tell. He wants to know what "this Orpheus thing" is that she is writing for Lawrence. And when he sees it, through eyes covered by a soldier husband's mask like Pentheus's,

he is cool and accusatory: "A bit dramatic, I don't like your *look not back*. It's Victorian."

Victorian meant old-fashioned, pre-war. It meant covered-up (pinned bodice, hair dressed high – no "letting down"), like the picture of Mother that H.D. kept in her red, plush-lined jewel box That cache also contained Lawrence's flaming letter that beckoned her to "come away." Aldington had said "Victorian" because he was jealous of the visible flame. Ever since H.D. lost their child in premature labor because of the way he'd bolted in Zeus-like with the war news of the Lusitania sinking (he was excited, H.D. devastated – now the Americans would join the war), she had shrunk from his intrusive physicality. He had a conventionally beautiful mistress upstairs, and now H.D. suffered this pull to Lawrence. It recalled the pull to the light she had felt that long-ago night with Ezra Pound when he said "she danced like a pink moth in the shrubbery." In *End to Torment* she said, "I danced in the garden in the moonlight, like a mad thing. *Maenad*."

When she was at home, there was the exact circle of light cast by the candle H.D. kept burning by the bed, a geometrical definition as exact as the clockface, a boundary eliminated in one flash of lightning. By nature a husband wants the predictable radiance to shine for him. A maenad is lit by another light that makes her wild. When Aldington saw his wife in the light of the blue flame licking out of the paper, he knew she was inspired by a God other than the one she could see in him. By being critical of her writing he was critical of her. He labeled her old-fashioned, stiff ("Victorian"), the way husbands have often labeled women who will no longer bend for them – as "lesbian," for example. In the *Bacchae* the messenger reports to an enraged Pentheus: the renegade women can be seen off in the wooded dell delighting in each other.

By the time H.D. found her way to Freud for analysis in 1933, she was living with Bryher (Winnefred Ellerman) and had a grown daughter who belonged to no father. Her writing registered the

shocks of the war years, the shattering of relationships, and the continued presence of Orpheus in her creative life. Freud, whom she usually called "the old Professor," became Asclepius, Hercules and then, ultimately, Orpheus. He "could charm the very beasts of the unconscious." Like Orpheus he had the power to enliven dead sticks and stones by bringing up buried thoughts, memories.

In fact he reminded her of the first Orpheus to beckon her. At a time when she felt it necessary to begin talking about that one, she noticed Freud's "charming wrinkled smile" that was a direct reminder of D. H. Lawrence. Lawrence, because of his intense focus on her, had tampered with the locked box lined with red velvet (that would in her late years become red roses to unfold "unseemly, impossible, even slightly scandalous," for a younger lover). Where Lawrence tampered, Freud tempered. Both were censured in their time. According to H.D., Freud "tempered the Victorian law for my generation." He functioned as *Lysios*, unbinding. At another time he was *Bromios* thundering at her, "I am an old man – you do not think it worth your while to love me." He was the old satyr, her Silenus, centurion at the gate. She said he reminded her of the centurion in Pompeii who did not run even when the fire and ashes began to rain.

H.D. fashioned the narrative of her life around this core of initiation and search. The image of who she is alters with the same protean fluidity as her description of Freud. She is Eurydice at the entrance to the underworld, Helen pacing the ramparts, Isis searching for her lost brother-lover Osiris. William Carlos Williams described her as a maenad who would initiate onlookers into "the mysteries of the vital cosmos."

The maenad's transformation historically was due to her being possessed by a force foreign to the ordinary, that urged her out of her senses into a body capable of extraordinary feats. A woman in maenadic possession could run for miles bare-footed in the snow. She might stop and start and dart like a deer. Snakes might be wound through the hair or drawn through her clothes without

biting, as is the case when the handler is caught in a healing frenzy. "Thunder from the mountains signaling" the coming of the God would change the look in her eyes and affect the carriage of her body. In paintings, the maenad is recognized by the way her head is thrown back and the erectness of her posture. Williams was once stunned by the sight of H.D.'s dancing with danger – caught up, enraptured in a violent thunderstorm. On another occasion he watched her wade out into a pounding surf that beat her senseless. (H.D., 1982, 8)

Bryher's first image of H.D. is different. Rather than see her as taken over by the God (which she would see often enough), Bryher saw her as instrument, as embodiment of the powerful blooming *thyrsus* that marked the end of the initiate's search. Describing herself in her initial approach to the cottage where H.D. was staying, Bryher writes:

This was the place. She knocked.

She was too old to be disappointed if an elderly woman in glasses bustled out. Poets, of course, were not what they wrote about. It was the mind that mattered.

A tall figure opened the door. Young. A spear flower if a spear could bloom. She looked up into eyes that had the sea in them, the fire and the colour and the splendour of it. A voice all wind and gull notes said:

"I was waiting for you to come." (Robinson, 230)

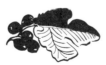

If H.D.'s exquisite example of a life suffered *sub specie* Dionysos/Orpheus – under the aspect of the God – helped cure the myopia of simple idealization, Jane Ellen Harrison's example secured the revision. Harrison was never mad enough to be a maenad. She was vibrant, enthusiastic, dramatic, passionate. All the words used to describe her were also used of H.D. They were strik-

ingly tall, handsome, green-eyed. Both wore classical drapery, lived deeply in the myths they studied, and took to task the rewriting of the Mysteries.

But the difference between them is suggested in the images of the poet dancing wildly in the storm while the astonished male looks on, and the classicist riding her high-wheeled bicycle – her silvery-green scarf billowing behind – with her cherished friend Francis Cornford pedaling alongside. Perhaps because of a Victorian dignity that was preserved in her manner, even as she was known for "destroying Victorian ideas" with her mind, Jane Harrison appeared self-possessed. She and Francis belonged to the Society of Heretics where fellows would gather to read fresh, brilliant papers revealing contrary views on classical subjects. She was in splendid control of her vehicle for expression – writing letters, lectures, books – always on a trail of discovery. And often with a fellow Oxford don beside her.

As a girl she wanted to grow up to be a poet, a scholar, a polar bear on an ice cap. None of these avenues were particularly acceptable, especially to the great-aunt who found a smuggled text in Jane's possession: "I do not see how Greek grammar is to help little Jane keep house when she has a home of her own." (Stewart, 6) Being housebound did not appeal to Jane in 1858 – "the dark ages" – or ever again. Her father finally consented to her taking the scholarship offered her at Cambridge, and at seventeen she was swept up into the swirl of *academe* where she slaked her thirst for poetry, became an unsurpassed scholar, and even in her late years – after seven languages, innumerable archaeological excursions, a world war, and greatly changed personal relationships – wrote a charming book on bears. Bears rivaled bulls for her attention.

She admitted "unbridled passion for the minotaur." When she wrote to her friend and colleague Gilbert Murray about the beast in the bowels of the labyrinth, she was writing at once about the mythological creature featured in the lecture she was at work on and about herself. She tells "G.M." that she is in the depths of depres-

sion because none of the others around her seem to feel that the Hornéd Horror has any significance. Between these friends there was a delightfully significant penchant for mythologizing each other and their work. Some years after Harrison was gone, when Linda Fierz-David came to the conclusion that "every woman houses a minotaur in the labyrinth of her bosom," she could have cited the elder Jane as source for personal, psychological revelation as surely as she cited Harrison the professor for her classical research in the Dionysian-Orphic tradition.

Francis Cornford and Jane Harrison used their regular bicycle rides to discuss work. Holidays served that purpose as well. When they went to the Bay of Naples they read five cantos of Dante aloud each day, translating as they proceeded. In Sweden they took up reading Selma Lägerlof in Swedish. Meanwhile, the correspondence between "J.E.H." and "G.M." went on so that the three scholars stayed in touch. Those letters were addressed to Ther from Ker. "Ther," as in *theriomorphic*, refers to animal form or beast. Often a bull, as in this case of lines Jane translated (in reference to Europa's bull) and directed to G.M. as a reminder of him: "No whit like other Thers is he, but mild and dear and meek; He has a wise heart like a man's. . . ." (Stewart, 34-35) She also addressed him as "dear Cheiron." Cheiron, like old Silenus, was a centaur who dispensed music and healing.

One letter in particular she addresses to this aspect of him, because he knows something about a healing she has just experienced. It comes from Switzerland where she had gone for "an electrical cure" at the clinic of Dr. Rothlisberger. She opens the letter by asking if he thinks a blasphemous Ker can be converted. A "Ker" being a spirit of the underworld to which she belonged. Behind this message of rebirth stands years of history which I abbreviate unconscionably by saying that Francis Cornford married Frances Darwin, leaving Jane doubly alone because she had been like an aunt to young Frances. The fact that she was behind the marriage (both Frances and Francis were almost young enough for Jane to be their

mother) did not keep the Hornéd Horror from rising in her breast. This is the beast of jealousy that is especially black when a woman finds her emptiness due to the loss of love filled with hatred for another woman whom she has also loved.

And now I must tell you a strange thing. I was wondering if I should tell you or not when your letter came and now, though I am a little afraid, for you know so well the deceitfulness of the human heart and may dash my hopes. Do you think a blasphemous Ker could be converted? Do you remember contending with me on the cliffs and maintaining that there was more in religion than the collective conscience? I think I know now at first hand that there is. Last night I was awake all night with misery and utter loneliness such as often comes upon me now that I have to go about alone – only it was worse than anything I have ever felt – like a black despair, and I was full of hate against Frances, unjustly of course, as the cause of my loneliness. I fell asleep at last and woke about six bathed in a most amazing bliss and feeling that all the world was new and in perfect peace. I can't describe it – the "New Birth" is the best – it was what they all try to describe, and it is what they mean by communion with God. Only it seems senseless to me to give it a name and yet I do not wonder for it is so personal.

Something physical has happened for when I went to Rothlisberger the moment he put his instrument to my pulse he said "Why this is all better". . . . (Stewart, 113)

Ker tells Ther that she "hasn't put it into psychology yet." Earlier in her life she would have said she hadn't put it into mythology yet. She found those impulses to be identical. According to the tiny gold-leaf Orphic tablets that fascinated them both (G.M. wrote the critical appendix on the tablets for Harrison's *Prolegomena to the Study of Greek Religion),* she had drunk in the night from the clear streams of Memory situated near the entrance to the initiate's underworld. The one stream of "unmindfulness" permits forgetting. The other of "remembering" reminds. A drink of this restorative

stream returns the initiate anew to herself. Jane Harrison's passions never waned, but rather ripened with her. "Even in old age you go on falling in love," she said in her *Reminiscence*.

Images of such women materialize as *aides mémoire* when we think of Freud's saying that the concern of psychoanalysis was "love and work." It was as true of Jane Harrison as it was of H.D. that she was unable to work unless she was in love. The loves of these "individual" or "odd" women, as they would have been called after the turn of the century, were unconventional. It is clear as we read them that Eros had shot them with a double-tipped arrow so that their desire always sought both a lover and a companion in the work. Sometimes the beloved was an actual person, another one among "the straggling company of brush and quill." (H.D.) Sometimes it was the poem itself, or the lecture, as when an ecstatic Jane Harrison announces: "Dionysus comes on Friday!"

A *thiasos* is a congregation of women attentive to the mystery in things. A gathering of people compelled to listen "for the echo of a whisper in the hiss of resin." H.D. wrote these words while burning pine cones in her solitary room at Küsnacht on the Zürichsee where she asked, "Who has been here before?/Was it Iacchus, Dionysus, Bacchus?/fragrance of grapes mingles with scent of cedar/ — and the hiss of resin/recalls a whisper/in a temple corridor—we are not alone." (1972, 102) She was not alone in her preoccupation. Several towns down on the shores of the same lake—unbeknownst to each other—at precisely the same time, and shortly before her death also, Linda Fierz-David was lecturing about the God ("Was it Iacchus, Dionysus, Bacchus?") whose coming generates community. The poet was never part of the same actual community. In fact she shunned Jung because, as she said, she "liked to take her alchemy straight." But she is part of the *unitas sororum* in our imagination,

the *thiasos* that extends backward to Elis and forward into our own time. When Lawrence described H.D. as Orphic, he was counting her among those women of his acquaintance who "inhabited an ecstatic, subtly intellectual underworld" like that of the Greek Mysteries.

We can see now what we could not see as girls, that those women – H.D. (in relation to Pound, Lawrence, Freud), Jane Ellen Harrison (in relation to Francis Cornford and Gilbert Murray), Linda Fierz-David (in relation to Jung "to whom she had an enormous transference") – needed men. Not to live with. Not as husbands. But as lovers of their souls. They needed and found men for inspiration. For energy. They then held this masculine source of generativity in their own hands as the initiate held "the rod of God," appropriating its power to her own uses. It is as if those women were transformers struck by lightning. "Thonner struck thing mad," as Joyce wrote. What they found on this particular path was not the slow thaw and gentle arousal characteristic of the mother-daughter emergence rites at Eleusis but the more violent injection of spirit characteristic of the woman-lover rites of Dionysos. "A certain woman loves a certain man" was the answer that gave one entry to a secret Roman organization. *"Cedo signum, si harunc Baccharum es"* ("Give the password if you are one of the Bacchants"). (Nilsson, 14)

When Linda Fierz-David asks plainly, "What, after all, is a woman without a man?", she is speaking out of this Dionysian tradition where a woman is struck, "fucked" (from *ficken*, "stricken," "struck") and moved by the bolt out of the blue. Semele is struck by "the hot splendor of the shaft of god." (Euripides) The initiate is struck by the angel's whip. Ariadne is struck by the realization of her abandonment on Naxos. She is also struck on that isle by the feathered shaft of Artemis which induces labor out of death (birthing one's next self) as surely as Zeus's shaft brought life out of the smoldering Semele. The movements are swift. This is the way of the *katabasis*, of the dark core and the sudden flash. It is the Turning

Point ("Fu" in the *I Ching*, hexagram 24), Earth above, Arousing thunder below.

Once one is struck, movement comes from below the surface, from within the body. Inspiration, deep-seated like the sibyl's, needs only to be aroused. When it happens, it feels like something has "hit" or "struck home." As if the source that tremendously moves us originates from the outside. Fierz-David is aware of the paradoxical origin of inspiration and movement so that, even as she says a woman needs a man, she notes that if a woman still sees the source, "the treasure, outside of herself in a man she is not ripe for it." (Jung, 109) A man may spark the transformation, but the blow of the whip that beats the initiate into the boundaries of her new form is delivered by a facet of her own femininity – the woman-angel who arrives with frightful capacity to quicken (Scene 7). She arrives with an intensity echoed in the first line of the poem "Ordeal" by the Romanian poet Nina Cassian, who says, "I promise to make you more alive than you've ever been. . . ."

In keeping with the intrauterine detail that has surprised us at turns throughout this chamber, we note that embryonic life does not begin gently. Once a sperm cell has struggled upstream and made its way into the ovum by penetrating a lattice-type structure (that resembles *in minutia* the wicker basket, the *liknon*, the *kista* of our Mysteries), the protoplasmic content begins to vibrate. Under high magnification it appears to be suffering violent agitation while the two pronuclei meet, merge, and enlarge. The fertilized egg is then struck repeatedly by tiny whip-like flagella that transport the ovum into the womb with the rhythm of constant beating. Once implanted in the bloodwall of the womb, the embryo settles down into a period of orderly development before beginning the tumultuous passage out. Then come the lightening, the rupture, and the

crowning – the data of birthing that were familiar to the Dionysian women who called their God's dwelling places *thalameuma*, secret chambers, cave shelters, wild interiors, birth recesses. (Segal, 84)

Every age sees Dionysos, and what is "Dionysian," according to its necessities. Where order reigns he is the instrument of frenzy. Where the sexes are too rigidly defined, he is the image of bisexuality. Where there is fragmentation and individual isolation, his coming generates community. (Hillman, *Myth,* 271) Linda Fierz-David did not make much of the community of women, the *thiasos,* that welcomed the initiate into her reframed world. This may be because of the emphasis placed on an *inner* congregation by Jungian individuation psychology. Or because the need for company was actually met more in her time than in ours. Losing one's friends is an often predictable hazard of undergoing the ritual descent of psychotherapy. Our focus changes. People who were once kin no longer see things as we do. Words take on new properties. Images speak. Values shift. Bodies alter.

In the ancient world this dis-orientation, and the subsequent need for re-orientation among friends, was recognized in certain cult practices. For example, after the initiatory isolation of a three-day underground burial at one of the sacred sites of Zeus, the dazed initiate was drawn out, seated on the lap of memory (throne of Mnemosyne), and then returned to a group of waiting friends where she regained her wits and the power of laughter. Such an embrace, offered by a community of others who know what the initiate has been through, is not part of the contemporary *rite de passage.* Perhaps that rare enclave of women in Zürich in the 1950s who listened to Fierz-David's interpretation of the frescoes recognized each other in the patterns of feminine relationships depicted on those walls and found themselves in good company.

It is fitting that the Empress Livia's statue stood at the entryway of the Villa that housed Fierz-David's imagination. Associated with companies of cultured women (the *conventus matronarum*), a stable forty-year rule, and the emergence of the moral and spiritual values of the European conservative nobility in Rome, the Empress's presence indicates that what goes on in the Villa goes on under her aegis. Her figure supports the reading of the room with emphasis on the dignified Orphic overlay rather than the mad Dionysian undercurrent. Her eye is a touch colder than the eye of the *Domina* in the warm chamber, but these women draw their power from a common attitude of "having arrived." Fierz-David's description of Livia's circle sparks associations to another, quite different, comparatively recent circle.

What many of Linda Fierz-David's peers recall of her are her elegance and her high standards – which she had occasion to impress upon them because of her role as the Analytical Psychology Club secretary for many years in Zürich. Hers was a critical position in that she created the ambience and framed the space out of which the collective, social image of the "Jungians" was born. Like the *Domina* of her speculations – who art historians think orchestrated the activity in the chamber, perhaps even commissioned the artist to paint the frescoes, and in any case sat in such a position that she became portal through which the uninitiated must pass – she dignified and colored the room.

"She observed everything," according to a student at the time. "She kept ceremony." (Her impression of analysis was that it should proceed in the manner of "two Chinamen over a cup of tea." Oddly reminiscent of a story that H.D. and Ezra Pound gave birth to the Imagist movement over cups of tea in a formal, fashionable British tea shop.) She set the standards of taste, dress, decorum. Set the schedule, arranged parties, chose the wine. She wielded the *thyrsus* in its late-date sense as the meter of propriety. This woman whose family had bequeathed her a far-ranging field of interests in politics, poetry, Brazilian business, "unconscious Croatian witchcraft,"

chiromancy, and medicine developed a distinct, sophisticated style in the Swiss psychology circle. Whether we think of her as *Domina*, dramaturg, or secretary (officer of "secrets"), her concern with detail, manner, and mode is a fitting attribute of one who observes rites that keep a Dionysian secret hidden.

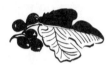

Turning to the frescoes for comment, we notice the initiate flanked by two small, winged Cupid figures in the closing panel (Scene 9). These winsome characters, who appeared regularly on vases and in wall paintings, are called *erotes*. Little life-spirits who attend to small matters. They are the life-impulses (or love-impulses) that adorn women, give color, water flowers, welcome strangers, set tea – delighting in the details of daily life in a way that is hardly possible when still in the *katabasis*. We might imagine the Fierz boys seeing their gracious mother accompanied at the piano by *erotes* in the enchanting late afternoon light.

But the image Heinrich Fierz insists upon is more striking, less expected. He sees her in the triumphant dance of two women in the eighth scene. One a well-dressed woman, in fact a "lady," appears anachronistically closer to our own time, and the other a naked Bacchante with her back to us who appears stretched her whole toe-to-fingertip height. They move in complementary fashion as modish does to modest. This is "the possibility of woman," he said, "The elegant circling lady, the dancing woman. My mother partook of each of these attitudes."

This portrait scene shows the moment of the initiate's entry into the *thiasos*. The dressed lady brings the naked one her *thyrsus* and the veil of the chosen. "Many are called, few are chosen." So goes the saying. In Orphic tradition it is "Many are the wandbearers, few the Bacchoi." Few actually arrive at the God-imbued climax, though quite a few hear the call. H.D., commenting on this phrase

in *Notes on Thought and Vision*, thought it pertained to passing into the final stage of initiation that follows the arousal of body and mind. Many experienced seekers take up the instruments of intellectual power, but few are inspired. In the vision behind her idea she saw someone passing by the so-called pornographic chambers at Pompeii, into another area where the feeling reaction would be formulated, and then into a small room, alone, "to make one's constatation" which was where we began in our effort to follow the initiate as she entered the mystery chamber to "assume the stance" of one who is ready.

The momentum of Linda Fierz-David's climactic inspiration carried her out to her Bollingen estate (old Professor Fierz sold Jung his adjacent land where he erected his tower) where she built a pavilion, her own Villa of Mysteries. On the walls she painted "mystic things, a secret language, a secret script." From time to time, according to her son's memory, "she burned a candle in this pavilion" that was otherwise only dimly lit by light from above.

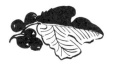

What began in adolescence as an attraction to those women – to their world-bridging achievement and high-browed intelligence – shifted to an interest in their shadows. To what they kept hidden. And to what the world, by dint of tradition, asked them to hide. Although they dared depart from convention (like maenads), many of them to live with women for example, while appearing to live for a man, they did not write explicitly about these relationships – especially the psychologists. Fierz-David was not one of those women in this regard, but rather an observer at the epicenter of the phenomenon. We know that when Jung encountered women who needed to work with a woman on emotional conflicts specific to being a woman, he referred analysands to her. He also instructed some of those analytical women in training to live with one another, so

one elder analyst on the Swiss side told me, because living alone would isolate them from the relational realm of their patients.

Zürich in the early days, and New York, London and San Francisco, hosted many couples of deeply non-conventional women dedicated to what the young H.D. called investigation of "the overmind," to what the Jungians called "the suprapersonal," and to what Jane Harrison, using the philosopher's term, would call "riding the ascending wave of the élan vital" over against "the descending wave of matter." All in search of the sublime. But suffering the daily trek through life and matter in the significant company of another woman. (Jane Harrison spent the last part of her life, nearly twenty years, with Hope Mirlees, "flashing eyed genius" who was her former pupil and "constant friend and companion.")

Not all of those women felt as extremely as my friend on the island in Maine who burned her personal correspondence but kept thousands of pages of active imagination because "only the impersonal is interesting," yet they were of the school that thought one's work should speak for itself. Her particular *opus* – a drama of inner characters unfolding a plot in years of mornings devoted to "listening" – begins with the entrance of a fiery young woman in a brilliant red dress who wears a single strand of perfect pearls. These pearls shine with the long-kept secret of storytellers as Isak Dinesen put it in her *Anecdotes of Destiny*: ". . . pearls are like poet's tales: disease turned into loveliness, at the same time transparent and opaque, secrets of the depths brought to light to please young women, who will recognize in them the deeper secrets of their own bosoms." (Thurman, 76)

It steadies us now as we stand facing an uncertain future (Scene 1), holding these gems passed on, to remember the essential grit at the core. Because of a constant, invisible irritant that would not let them rest in accustomed roles, those women fashioned unique and substantial works of their lives. Knowing something of the Dionysian dark that roots their lustrous creations tends to encourage those of us who follow.

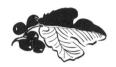

List of References

Artaud, Antonin. *The Theater and Its Double*. New York: Grove Press, 1958.

Bradway, Katherine. *Villa of Mysteries: Pompeiian Initiation Rites of Women*. San Francisco: C. G. Jung Institute, 1982.

Cixous, Hélène. "Come the Following Chapter." Translated by Stan Theis. *enclitic* 4 (Fall 1980): 44–58.

Dodds, E. R. *The Greeks and the Irrational*. Berkeley: University of California Press, 1951.

Eliade, Mircea. *Rites and Symbols of Initiation*. New York: Harper and Row, 1958.

Euripides. *The Bacchae*. Translated by Michael Cacoyannis. New York: New American Library, 1982.

Fierz-David, Linda. *The Dream of Poliphilo*. Translated by Mary Hottinger. Bollingen Series xxv. New York: Pantheon Books, 1950. (Reprinted: Dallas: Spring Publications, 1987)

Fierz-David, Linda. *Women's Dionysian Initiation: The Villa of Mysteries in Pompeii*. Dallas: Spring Publications, 1988.

Harrison, Jane Ellen. *Prolegomena to the Study of Greek Religion*. Cambridge: Cambridge University Press, 1903.

H.D. *Bid Me to Live*. New York: Grove Press, 1960.

_____. *Collected Poems 1912–1944* (including "At Eleusis"). Edited by Louis Martz. New York: New Directions, 1983.

_____. *Hermetic Definition*. New York: New Directions, 1972.

_____. *HERmione*. New York: New Directions, 1981.

_____. *Notes on Thought and Vision*. San Francisco: City Lights Books, 1982.

_____. *Tribute to Freud* (including "Writing on the Wall" and "Advent"). New York: McGraw-Hill, 1974.

Henderson, Jeffrey. *The Maculate Muse: Obscene Language in Attic Comedy*. New Haven: Yale University Press, 1975.

Henderson, Joseph L. "Ancient Myths and Modern Man." *In Man and His Symbols,* edited by C. G. Jung. London: Aldus Books, 1964.

Hillman, James. "Dionysus in Jung's Writings." In *Facing the Gods*. Dallas: Spring Publications, 1980.

_____. "An Essay on Pan." In *Pan and the Nightmare* (with W. H. Roscher). New York/Zürich: Spring Publications, 1972.

_____. *The Myth of Analysis*. Evanston: Northwestern University Press, 1972.

Jung, C. G. *The Visions Seminars*. Zürich: Spring Publications, 1976.

Keller, Tina. "Beginnings of Active Imagination: Analysis with C. G. Jung and Toni Wolff, 1915–1928." *Spring 1982*: 279–94.

Kerényi, Carl. *Dionysos: Archetypal Image of Indestructible Life*. Bollingen Series LXV.2. Princeton: Princeton University Press, 1976.

Nilsson, Martin P. *The Dionysiac Mysteries in the Hellenistic and Roman Age*. New York: Arno, 1975.

Robinson, Janice S. *H.D.: The Life and Work of an American Poet*. Boston: Houghton Mifflin, 1982.

Segal, Charles. *Dionysiac Poetics and Euripides' Bacchae*. Princeton: Princeton University Press, 1982.

Stewart, Jessie G. *Jane Ellen Harrison: A Portrait from Letters*. London: Merlin Press, 1959.

Thurman, Judith. *Isak Dinesen: The Life of a Storyteller*. New York: St. Martins Press, 1982.

van der Post, Laurens. *Jung and the Story of Our Time*. New York: Pantheon Books, 1975.

Perspectives on the Feminine

Animus and Anima Emma Jung
Two classic papers on the elemental persons of the psyche examine both animus and anima as they appear in behavior, fantasies, dreams, and mythology. Accessible, incisive, and practical, this book maps a way toward the union of opposites and the emergence of the Self. (94 pp.)

Goddesses of Sun and Moon Karl Kerényi
Restoring passionate feminine consciousness to its rightful place both in politics and in the economy of the psyche, these four papers explore the mythemes of Circe, the enchantress; Medea, the murderess; Aphrodite, the golden one; and Niobe of the Moon. Together they lend a deep psychological orientation to some puzzling and controversial issues: feminism, the occult, aesthetics, madness, dreams, even terrorism. (84 pp.)

Pagan Meditations Ginette Paris
An appreciation of three Greek Goddesses as values of importance to our twentieth-century collective life: Aphrodite as beauty and civilized sexuality; Artemis as solitude, ecological significance, and a perspective on abortion; and Hestia as warm hearth, security, and stability. A contribution to *imaginative* feminism, this book addresses both the meditative interior of each person and the community of culture. (204 pp.)

Problems of the Feminine in Fairytales Marie-Louise von Franz
Motifs relevant for women and the feminine side of men explored and amplified. Dr. von Franz offers practical psychological counsel drawn from fairytales of Russian, German, Eskimo, and Scandinavian origin. Used internationally in psychological study groups. Index. (200 pp.)

Starving Women: A Psychology of Anorexia Nervosa
 Angelyn Spignesi
Phenomenologically examines the shapes, textures, colors, voices, and boundaries of the anorexic woman's inner world, one deeply ritualistic and sacrificial, featuring pernicious tyrants, grasping maidens, and darkened mothers. The author draws upon current medical research, psychiatric and Freudian interpretations, and the mythemes of Demeter and Persephone, arriving at the figure of the 'starving woman' in us each. (140 pp.)

Spring Publications, Inc. ● P.O. Box 222069 ● Dallas, TX 75222